CENTRAL LEEDS

THROUGH TIME

Paul Chrystal

AMBERLEY

Acknowledgements

As with *Leeds in 50 Buildings* (2016), the people of Leeds have been very supportive and generous in the help they have given in the compilation of this book. Without them the book would be considerably less informative and significantly less colourful. I would, therefore, like to thank the following individuals for their assistance in the provision of information and photography: Anys Williams at Anita Morris Associates for the Corn Exchange images; Sally Hughes, assistant librarian manager at the Local and Family History Library; Leeds Central Library for the Leodis images; Peter Higginbotham at workhouses.org.uk; Ollie Jenkins, the picture house administrator at Hyde Park Picture House; Andrew Bannister, head of media relations at Leeds Teaching Hospitals NHS Trust; and Siân Yates, archivist at Group Archives (Edinburgh), Lloyds Banking Group Archives.

Also by the author

Leeds in 50 Buildings
Old Saltaire & Shipley
Tadcaster Through Time
Selby & Goole Through Time
The Vale of York Through Time
The Pubs of Harrogate & Knaresborough
Secret Harrogate
The North York Moors Through Time
Secret Knaresborough
Confectionery in Yorkshire
Huddersfield Through Time
The Rowntree Family of York
Changing Scarborough

For a full list please go to www.paulchrystal.com. Unless acknowledged otherwise, all modern photography is © Paul Chrystal. Lower front cover image courtesy of Anys Williams at Anita Morris Associates; back cover illustrations show the County Arcade in 1907 and 2016.

First published 2016

Amberley Publishing
The Hill, Stroud, Gloucestershire, GL5 4EP
www.amberley-books.com

Copyright © Paul Chrystal, 2016

The right of Paul Chrystal to be identified as the Author of this work has been asserted in accordance with the Copyrights, Designs and Patents Act 1988.

ISBN 978 1 4456 5644 1 (print)
ISBN 978 1 4456 5645 8 (ebook)

British Library Cataloguing in Publication Data.
A catalogue record for this book is available from the British Library.

Typesetting by Amberley Publishing.
Printed in Great Britain.

Introduction

It is the Venerable Bede who provides our introduction to the settlement of Leeds; this first record is found within *Historia Ecclesiastica* (Book 2 Chapter 14), written around AD 731, where he describes an altar from a church built by Edwin of Northumbria, in 'the region known as Loidis', a Welsh-speaking subdivision of Elmet that was later a part of the Kingdom of Northumbria. 'Leodis' may mean 'people of the flowing river', the river being the Aire on which Leeds stands. A reference to 'Ledes' also appears in the Domesday Book of 1086.

After the Norman Conquest, Leeds was spared the devastation and depredation of the rapacious Harrying of the North by William I. Apart from the evidence within *The Annals of Yorkshire* (1862), *The Leeds Guide of 1837* states that Ilbert de Lacy built a castle around 1080 on Mill Hill – today's City Square – besieged by Stephen on his way to Scotland in 1139. The castle occupied the site surrounded by Mill Hill, Bishopgate, and the western part of Boar Lane. According to the *Hardynge Chronicle* in 1399, Richard II was imprisoned at Leeds before being moved to Pontefract for execution.

In 1207, Leeds received its first charter, leading to a new town being laid out along one street, overseen by Maurice de Gant, Lord of the Manor. This was Brigg Gata, later named Briggate (*brycg* is the Old English for bridge and *gata* is Old Norse for a way or street) and was wide enough to support a bustling market. The Poll Tax of 1379 reveals that the population was less than 300, making Leeds one of the smallest towns in Yorkshire – Snaith, Ripon, Tickhill and Selby were larger.

Agriculture was still the principal economy here and the Tudors saw Leeds become an established cloth-trading town. In 1536, the traveller and poet John Leland described Leeds as 'two miles lower than Christal [Kirkstall] Abbey, on Aire river, a praty [pretty] market town which stondith most by clothing having one paroche churche reasonably well buildid and was as large as Bradford, though not so quik'.

The fearless Celia Fiennes visited Leeds and, although she seemed more preoccupied with the price and strength of beer and whether her cheese sandwich should be on the house or not, she provides a contemporary picture of the town:

> Leeds is a Large town, severall Large streetes, Cleane and well pitch'd and good houses all built of stone ... This is Esteemed the Wealthyest town of its bigness in the Country its manufacture is ye woollen Cloth-the Yorkshire Cloth in wch they are all Employ'd and are Esteemed very Rich and very proud.

Through England On a Side Saddle in the Time of William and Mary (1698)

Around the same time, Ralph Thoresby (1658–1725), the North's answer to Samuel Pepys, kept a diary and published his famous *Ducatus Leodiensis* (1715), the 'First History of Leeds'. The city's historical society, formed in 1889, was named after him.

By the eighteenth century, Leeds was largely a mercantile town. In the 1770s, Leeds merchants contributed 30 per cent of the country's woollen exports, valued at £1.5 million; seventy years previously, Yorkshire accounted for only 20 per cent of the nation's exports. There were, of course, other industries. Leeds Pottery was founded in 1770, there were brick makers, coach

makers, clockmakers, booksellers and jewellers, and the first newspaper in Leeds went to press in 1718. Over the years, trade included flax, cotton, silk, engineering, locomotives, carpets, off-the-peg clothing at Burton's, brewing at Tetleys from 1822, confectionery at Quaker Henry Thorne at Kirkstall, military shell filling at Barnbow and tanks at Vickers.

The population exploded from 10,000 in the late seventeenth century to 30,000 in the late eighteenth. By the standards of the time it was a large town. The Industrial Revolution fuelled population growth: Leeds's industrial resurgence had been galvanised by the opening of the Aire & Calder Navigation in 1699, the Leeds and Liverpool Canal in 1816 and the railways from 1834.

By 1841 the population of Leeds was 88,000. At the end of the century, the *Yorkshire Factory Times* described Leeds as 'a miniature London', and on 11 September 1858, *The Illustrated London News* reported that Leeds was the 'largest and most flourishing' city in Yorkshire. The population in 1851 reached 172,270 and the number of inhabited houses was 36,165.

As in other cities, Leeds faced a critical housing problem with many of its squalid back-to-back houses condemned as unfit for human habitation. During the interwar years, sprawling council estates and private housing were built. The most interesting, and disastrous, of these schemes was Quarry Hill Flats, built between 1935 and 1941, providing homes for over 3,000 people. During the Second World War, seventy-seven Leeds people were killed and 197 buildings were destroyed.

In the twenty-first century, Leeds functions as one of eight core cities in the Core City Group that act as a hub to their respective regions. Leeds is a vital new-media and technology entrepôt; around 35 per cent of the country's email traffic is generated here; it is the second largest IT employer in England and Leeds Arena provides a state-of-the-art concert venue to equal any other in the country.

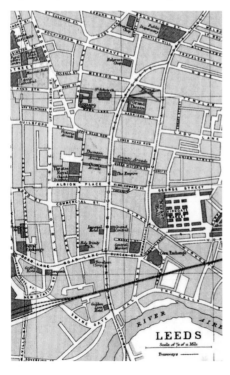

A map of Central Leeds published by Bartholomew of Edinburgh in 1909.

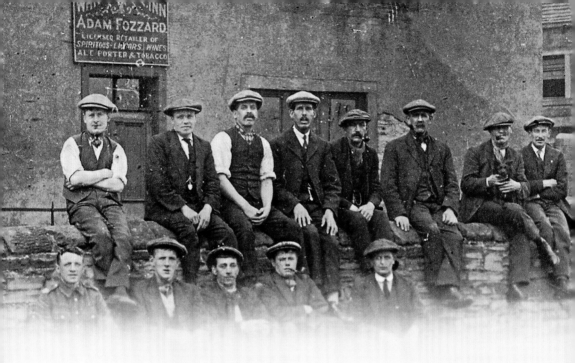

CHAPTER 1

People

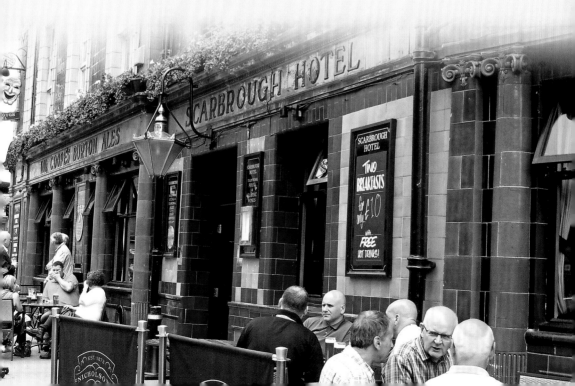

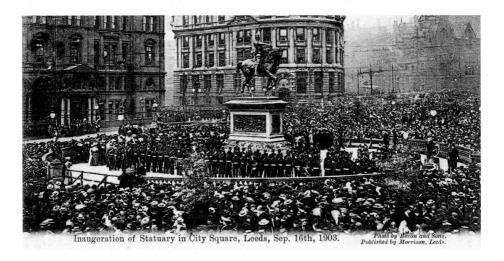

Inaugeration of Statuary in City Square, Leeds, Sep. 16th, 1903.

Photo by Bacon and Sons.
Published by Morrison, Leeds.

White Horse Inn and a Black Prince

The old image on page 5 shows thirteen happy locals and one dog at the White Horse Inn in Baghill Green, West Ardsley, around 1917. Note the soldier on the left. Adam Fozzard is third from the left; his brother Rack, the Knur and Spell champion, is on his right. The pub closed in 1926 and was demolished in the 1950s. In 1960, Thomas Gomersall, mineral water manufacturer, built a house on the site. The new image shows a similar group outside the Scarbrough Hotel in June 2016. On this page, the Black Prince opens for business in 1903. The Black Prince (son of Edward III) has nothing much to do with Leeds; he was a gift from Col Thomas Walter Harding, Lord Mayor of Leeds, between 1898–89, and was someone Harding admired, symbolising the virtues of democracy and chivalry. A nymph stands in front of the prince.

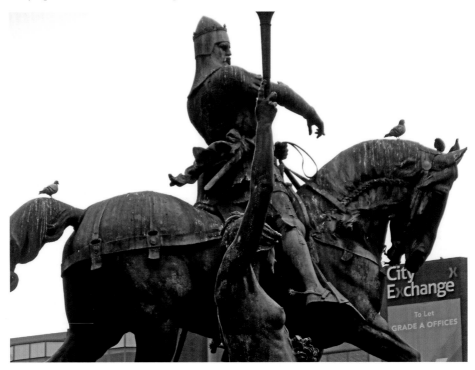

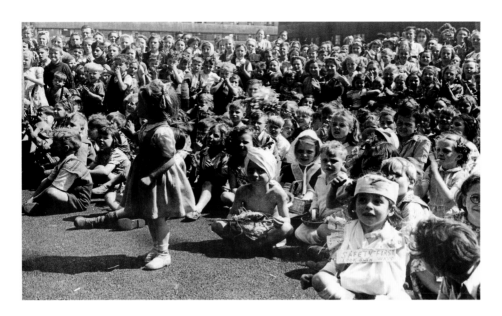

Fancy Dress at Quarry Hill

This took place at the July 1951 Quarry Hill Carnival – 500 children entered. The original plan for Quarry Hill was for 800 flats, which was increased to 938. In addition, there was a community hall with seating for 520 people, including a stage and dressing rooms (never built), twenty shops (few opened), indoor and outdoor swimming pools, a paddling pool, courtyards and gardens. There was to be an estate nursery, playgrounds, lawns and recreation areas, a communal laundry with dryers (drying of clothes on the balconies was prohibited), and, to end it all, an estate mortuary. Eighty-eight two-person passenger lifts were fitted. The lower image shows the slum conditions that were prevalent throughout Leeds, and it was this that the Quarry Hill development was intended to put an end to. (Courtesy of Leodis; Leeds Library & Information Services)

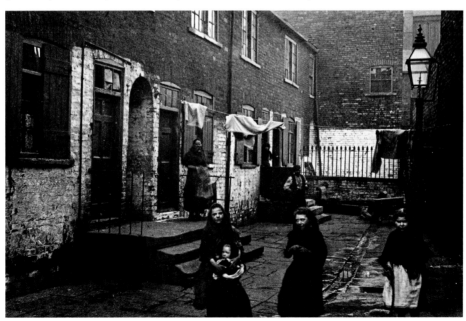

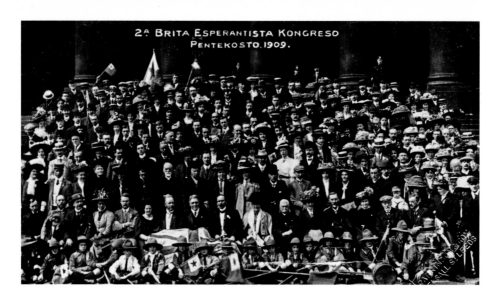

The Second British Esperanto Congress, 1909
On the steps of the town hall. Esperanto (meaning 'one who hopes') is the most widely spoken artificial language in the world. Its name comes from Doktoro Esperanto, the pseudonym under which physician and linguist L. L. Zamenhof published the first book about Esperanto, the *Unua Libro*, in 1887. Zamenhof's aim was 'to create an easy-to-learn, politically neutral language that would transcend nationality and foster peace and international understanding between people with different languages'. Up to 2 million people worldwide routinely speak Esperanto, including 1,000 native speakers who learned Esperanto from birth. The modern picture shows preparations for seating at the World Triathlon in Millennium Square in June 2016 when over 5,000 triathletes of all levels of ability competed on the unique 'point to point' course around Leeds.

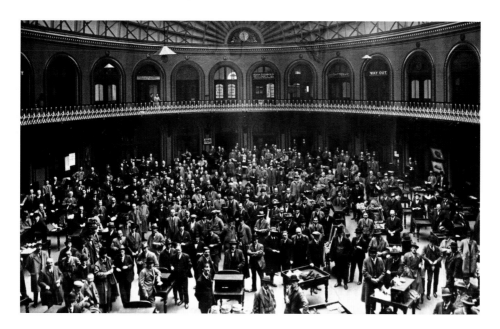

The Corn Exchange

Corn has been formally traded in Leeds since the seventeenth century when the corn market was at the top of Briggate, between the Market Cross and New Street (now New Briggate). Growing trade led, in 1827, to the building of a corn exchange at the top of Briggate, but by the mid-nineteenth century this also proved too small. So, in 1860, a new corn exchange was proposed; it featured a large central space surrounded by fifty-six offices, accessed by arched doorways – some of them opened onto the street, while others opened into the interior of the building. Corn was stored in the huge basement area. It was also used as the headquarters of the fire brigade for a while. The photos show the corn exchange in 1930 and 2014. (Modern image courtesy of Anys Williams at Anita Morris Asssociates)

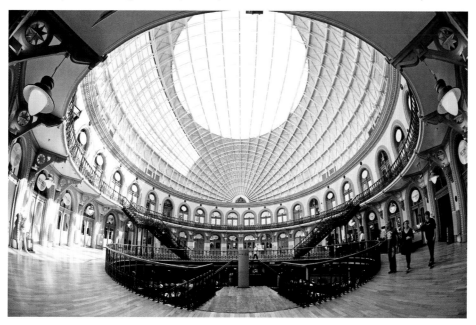

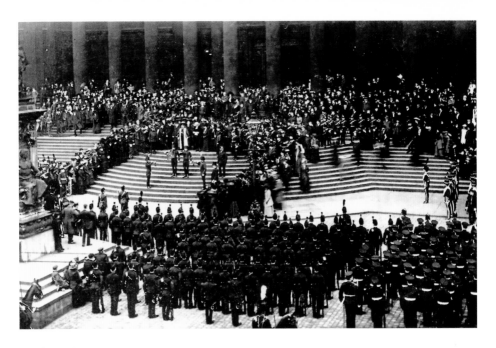

Proclamation Day, 1910

Proclamation Day is the name of holidays or other anniversaries which commemorate or mark an important proclamation. In this case, it was the Proclamation of George V's accession to the throne on 10 May 1910 at the City Hall. The modern image shows the same steps decked out for the World Triathlon.

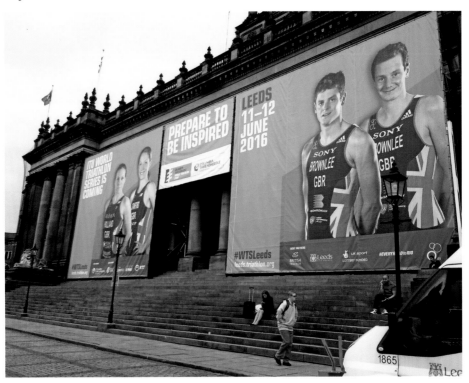

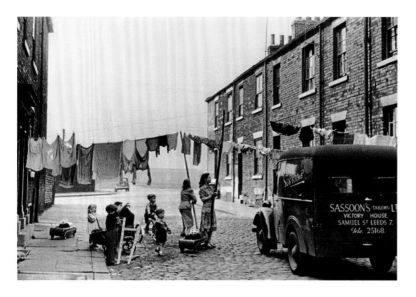

Washing Day

In East Grove Street, Burmantofts, probably a Monday. In the photo below, Mr and Mrs Horace Fawcett relax in their air-raid shelter in Cardigan Avenue, Burley, October 1940 – actually a very comfortable reinforced coal cellar. The Leodis website states:

> [T]he Fawcetts were held up as a shining example of resourcefulness and ingenuity. When members of the ARP came to inspect this shelter, they found the walls neatly papered, electric lighting and a heater installed, chairs and a table, and pictures on the wall, with a cot for the baby in the corner. 'It is a grand piece of work' was the comment of Cllr. HW Sellars, ARP chairman.

Many others moaned about their shelters. (Courtesy of Marc Riboud, 1954, and Leodis; Leeds Library & Information Services)

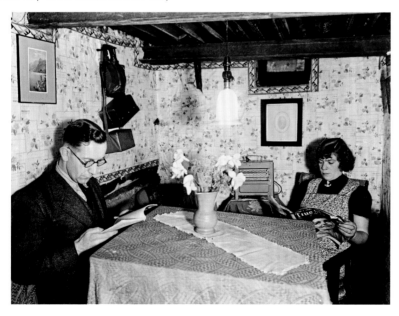

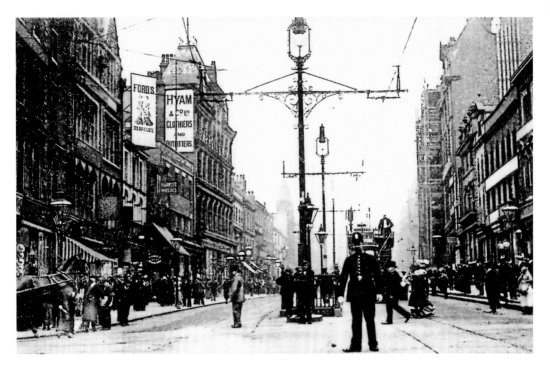

Policemen at Work
In Briggate in the 1900s, and in the 1930s (lower). The Imperial Hotel and Samuel's the jewellers are on the left in the upper shot while Boots is there on the right in the lower shot.

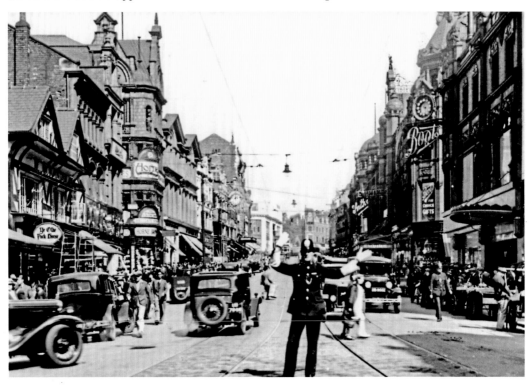

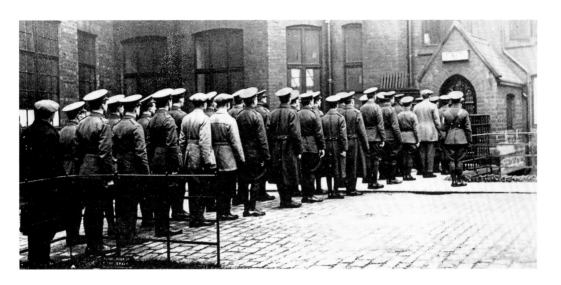

The Officer Training Corps

Leeds University OTC members lining up to sign up in 1914. During the war, 1,204 cadets did so. The lower photo shows Barnbow girls making box lids for cartridge-packing cases out of empty propellant boxes. They are using circular saws (without protective guards, of course) to cut the wood to size to make the box lids, the matériel from waste material. On Tuesday 5 December 1916, 170 women and girls had just started their night shift: 4.5-inch shells were being filled, fused, and packed in Room 42. At 10.27 p.m., there was a massive explosion that killed thirty-five women outright and maimed and injured many more. Many of the dead were only identifiable by the identity disks. None of this was made public until 1924; at the time, death notices appeared in the *Yorkshire Evening Post*, simply stating cause of death as 'killed by accident'. (Courtesy of Leodis; Leeds Library & Information Services)

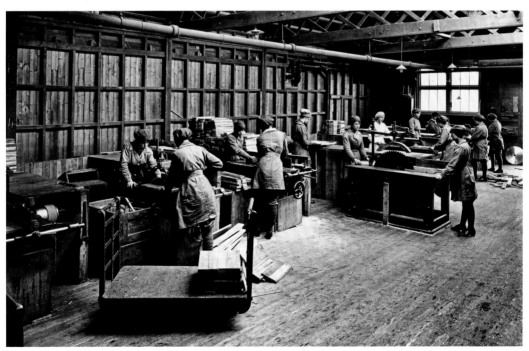

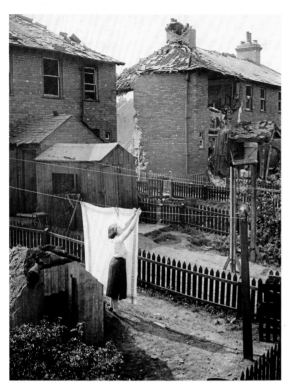

Air-Raid Damage
An Anderson Shelter. During the war seventy-seven people were killed and 327 injured in nine raids; 7,623 houses were destroyed and 197 other buildings. The lower photo shows how the Luftwaffe neatly converted this semi into a detached house on 22 September 1941 in a cul-de-sac off Cliff Road. (Courtesy of Leodis; Leeds Library & Information Services)

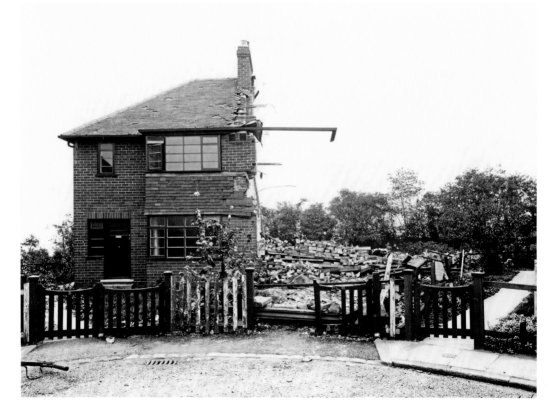

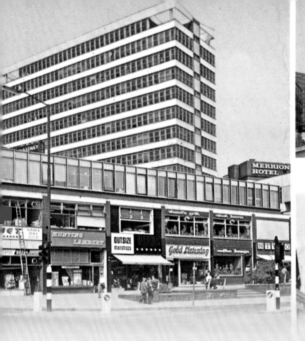
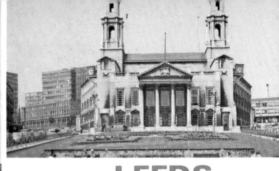

LEEDS

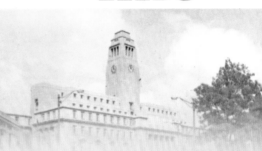

CHAPTER 2

Buildings

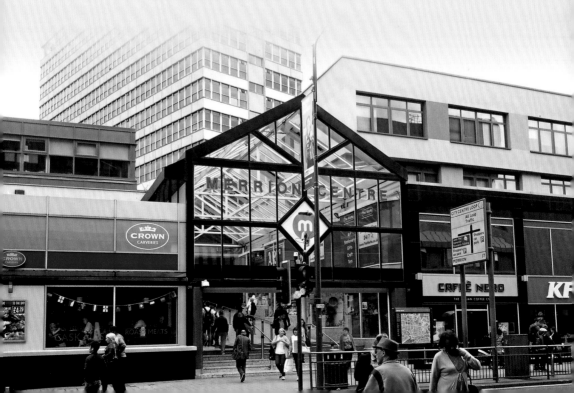

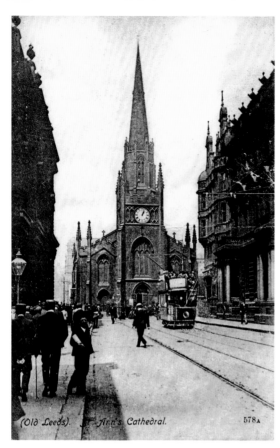

(Old Leeds). St. Ann's Cathedral. 578A

St Anne's Cathedral

Leeds Cathedral, known as St Anne's Cathedral, is the Roman Catholic cathedral of the diocese of Leeds, and is the seat of the bishop of Leeds. The city of Leeds does not have a Church of England cathedral because it was in the Anglican diocese of Ripon and Leeds. The original cathedral was in St Anne's Church in 1878 and was demolished around 1900. The current cathedral building on Cookridge Street was completed in 1904, and was restored in 2006.

The card on page 15 shows the Merrion Centre, the Civic Hall and the university, with the refurbished Merrion Centre in 2016 below.

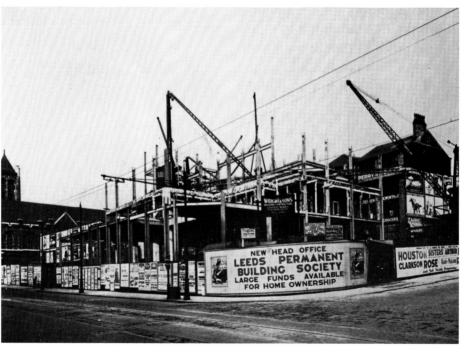

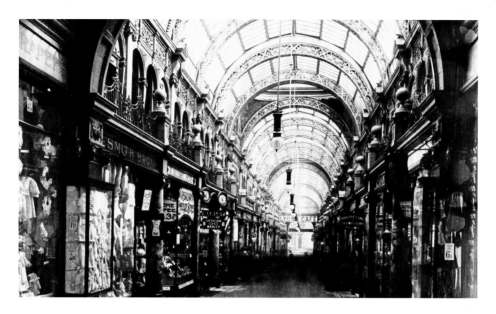

County Arcade, 1907

At the western end of County Arcade was The Bazaar, a two-storey emporium, the lower level selling meat and the upper level fancy goods and haberdashery. Men and women were segregated – men downstairs, women upstairs – with no chatting, no drinking or eating behind the counters, and none of that wearing of bonnets by the women. County Arcade and Cross Arcade were built between 1898 and 1903 on the site of the White Horse Yard, creating a new street on each side of the arcade: Wood Street became Queen Victoria Street, and Cheapside became King Edward Street on the site of the New Shambles and the Fish Market. The vaulted ceiling is glass and has three domes displaying mosaic figures representing liberty, commerce, labour and art. Lyons Café at the end was previously known as the Carlton Café and the Ceylon Café.

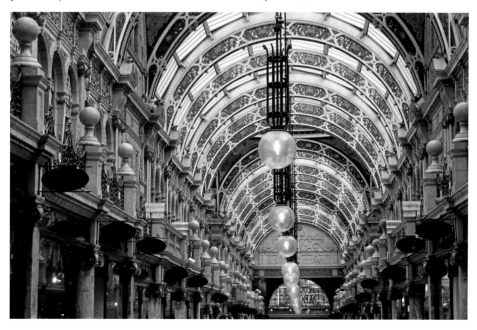

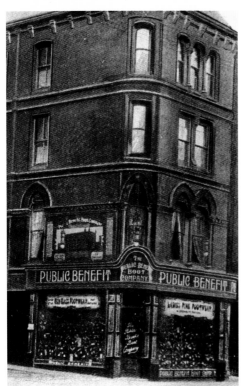

The Public Benefit Boot Co., Boar Lane
William Henry Franklin opened up in modest premises in Hull in 1875. By the end of the century this had blossomed into a nationwide network of 200 boot stores, several repair shops and four modern factories stretching from Newcastle to Cornwall, South Wales and Ireland. The Public Benefit Boot Co. sold footwear cheaper than most of their competitors and the profits were ploughed back into the business, enabling new stores to be opened. According to Ancestry's Genealogy records, the company's advertising consisted of a

giant-size boot that was regularly paraded around Yorkshire towns and villages on a flat horse-drawn cart. The rim of the boot was about four metres above the road and the driver's figure emerged from the top of the boot. A man ringing a bell and calling out the virtues of Benefit Boots usually preceded the enormous horse-drawn boot.

The headquarters were in St Paul's Street in this distinctive Moorish building.

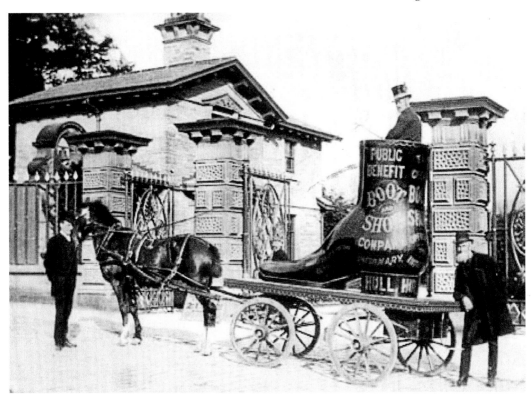

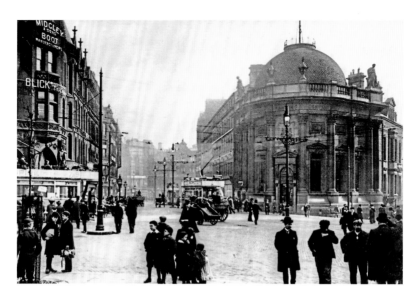

The Yorkshire Banking Co., Boar Lane

The headquarters of the Yorkshire Banking Co., on the corner of Boar Lane and Bishopgate. The impressive building opened in June 1899 and was built from granite with Corinthian columns and balustrading. The statues seen on either side of the roof represent personifications of manufacture and agriculture. Above the windows, carved panels depict the coats of arms of major towns and cities where other branches of the Yorkshire Banking Co. were located. The City of Leeds insignia is above the door and shows three owls, three stars and the fleece. The building has a 40-foot-diameter copper dome with an iron corona containing a skylight in the centre. The lower image depicts the Leeds Permanent Building Society building in Park Lane. (Courtesy of Lloyds Banking Group plc Archives)

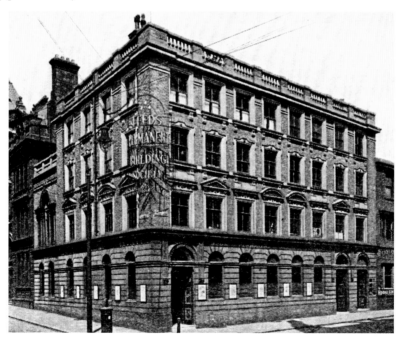

Queens

The art deco Grade II-listed building that was the Queen's Hotel, now just the plain Queens, dominates City Square in this view. The hotel opened in 1937 to replace the original hotel built on the same site in 1863. The new photo shows the elegant foyer in 2016.

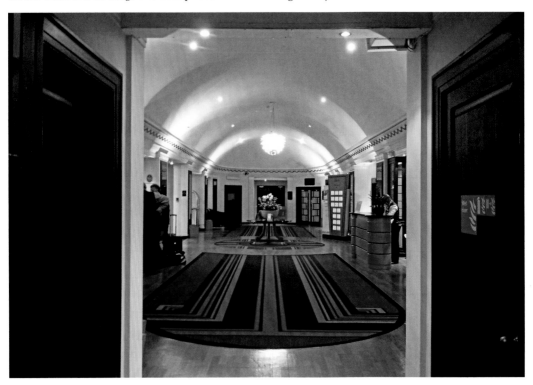

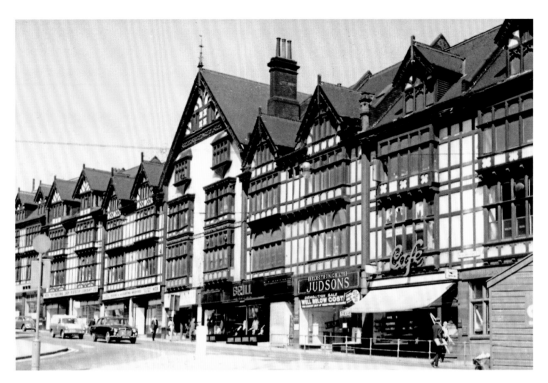

New Briggate

Pictured here in 1967, many of the early 1900s properties built on New Briggate were demolished to accommodate the new ring road and, in the 1970s, there were plans to demolish all the buildings between Boar Lane and the railway viaduct to make way for a new shopping centre. Leeds Civic Trust and the Victorian Society tried to save the buildings but sadly failed, although the shopping centre did not see the light of day. The buildings on Boar Lane survived but sadly the houses on Briggate, including Thomas Lee's house, and the yards behind were demolished. The prestigious Harvey Nichols is in the modern photograph.

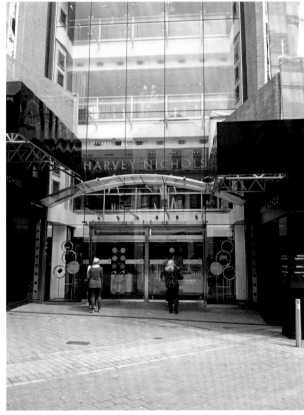

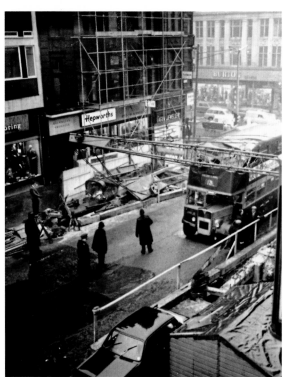

Crane Accident

Burton can be seen over the road on Briggate. The store was opened as a Lewis's department store on 17 September 1932. Lewis's had a greater variety of goods than any other store in Leeds. Over 100,000 people were present on the opening day. 'Ask Me' girls helped shoppers with the navigation of the 157 departments that sold everything from furniture to food. The first escalators to be installed in Leeds were featured within this store. The only item to run out that day were lobsters, which cost 9*d* each. The crane incident occurred on 29 December 1966 when the No. 12 bus to Vicar Lane was moving along Briggate and hit the jib of a crane working on a subway at the Boar Lane junction. There were no injuries. Cranes at work in 2016 around Leeds Beckett University are shown in the newer picture.

The Bread Arch

On 5 October 1894, the citizens of Leeds built an archway made of bread to mark the visit by the Duke and Duchess of York (the future King George V and Queen Mary) who were there to open the Medical School and College Hall of Yorkshire College (now Leeds University). The novel structure spanned the width of Commercial Street near Briggate and weighed 5 tons, made of white, brown and spiced loaves. It was the creation of Henry Child, who ran the Mitre Hotel to which the arch was attached. William Morris, who ran a bakery in Pack Horse Yard, baked the bread, which was the equivalent of hundreds of loaves, the flour for which cost £20 and was paid for by Henry Child. The plan was to distribute the loaves to the poor after the visit but rain scuppered the event. Commercial Street is shown today with its glass arch.

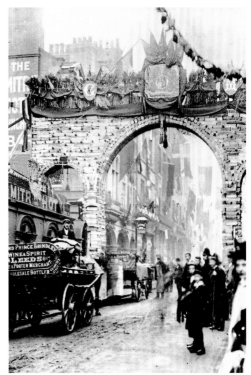

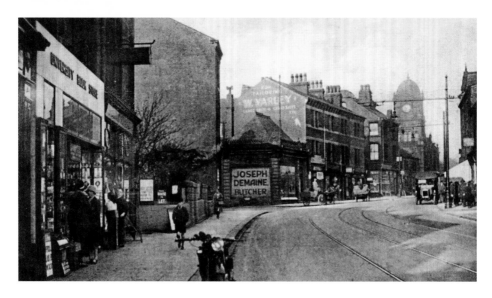

University Bookshops
The old and the new bookshops were and are on Woodhouse Lane.

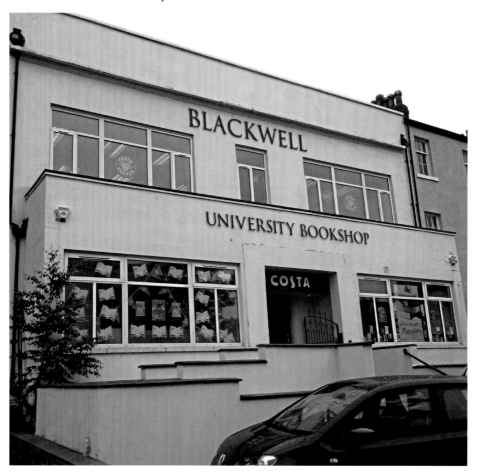

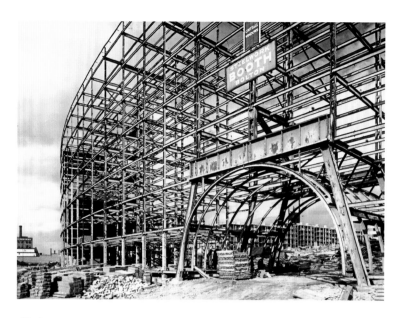

Quarry Hill Flats, 1939
Between 1938 and 1978, Quarry Hill was the biggest social housing complex in the UK. Its design owed much to such modernist developments as La Cité de la Muette in Paris and the Karl-Marx-Hof in Vienna. The homes at Quarry Hill boasted modern features such as solid fuel ranges, electric lighting, a state-of-the-art (but inefficient) refuse Garchey disposal system and communal facilities. The top picture shows Quarry Hill under construction. (Courtesy of Leodis; Leeds Library & Information Services) The lower picture shows demolition in full swing in 1978 on a card entitled 'Noel and His Lads'. This was the last standing arch at Quarry Hill. (Courtesy of Peter Mitchell)

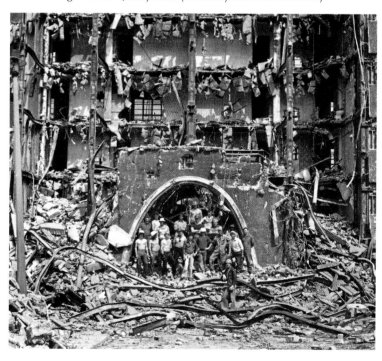

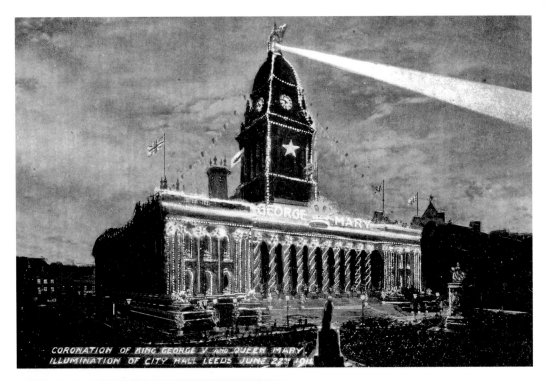

CORONATION OF KING GEORGE V AND QUEEN MARY
ILLUMINATION OF CITY HALL LEEDS JUNE 22ᴺᴰ 1911

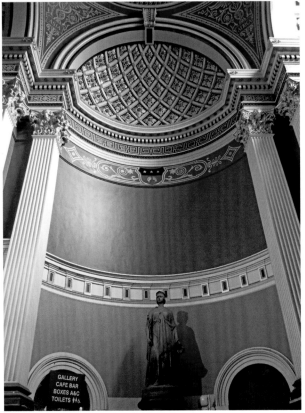

The Illuminated City Hall
The City Hall illuminated on 22 June 1911 to celebrate the coronation of George V and Queen Mary. Built on Park Lane and now The Headrow, the town hall is a symbol of the grandeur that was Victorian Leeds; it was an expression of civic pride and a reflection of the wealth brought to the city by the textile industries. The stunning entrance hall to the Town Hall is seen in the 2016 picture.

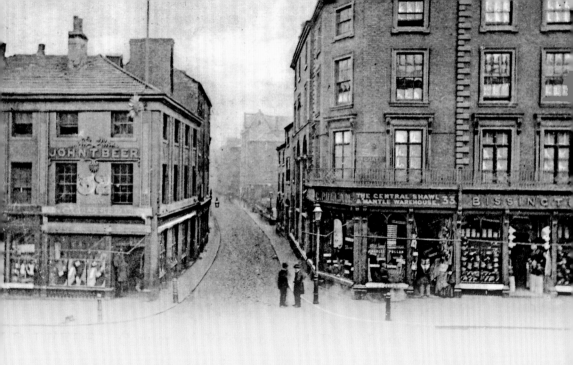

CHAPTER 3

Streets

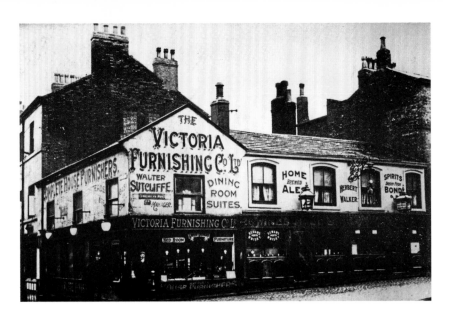

Albion and Guildford Streets

The picture on page 27 shows the corner of Briggate and Boar Lane, with John T. Beer, the tailors, at No. 32 Briggate on the left and Bissingtons, the Central Shawl & Mantle Warehouse, on the right. John T. Beer was famous for distributing copies of his poems to advertise his wares. The impressive statue in Briggate is of Minerva, Greek goddess of wisdom, with her owl tiara, sculpted by Andy Scott. The upper image on this page shows Burley Bar on the corner of Albion and Guildford Streets in 1906 – the westward limit of the city then. The shops are more than 200 years old and included a tobacconists, watchmaker, fruit shop, and beerhouse run by Walter Prestage Pilling. Leeds and Holbeck Building Society bought the site and built their offices on it. The Victoria Furnishing Co. occupied this site from 1900–07. The Malt Shovel next door dates back to 1798; the site housed a Barclays Bank in 1936.

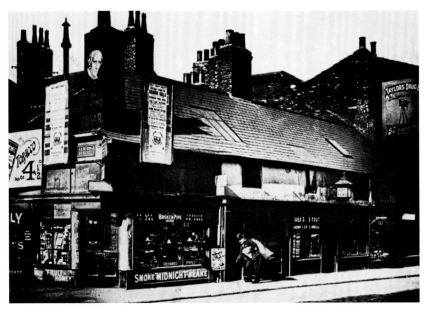

28

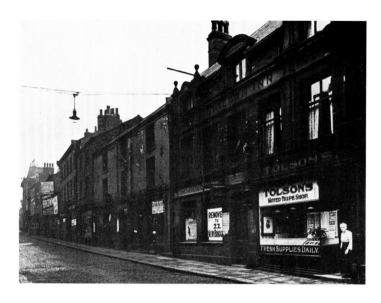

Tripe in Lowerhead Row

Looking west in 1928. Some of the shops to the left of the Unicorn Inn displayed iron Templar crosses on the front. This indicated that these properties were tenanted from the manor of Whitkirk, which belonged to the Order of St John of Jerusalem rather than Leeds. The inhabitants of the Manor of Leeds were compelled to have their corn ground at the Kings Mill; a court case in 1787 decided that the tenants of Whitkirk were exempted and they displayed the Templar cross to indicate this. Mrs Isabella Tolson ran the tripe – shop until it fell victim to road widening in 1928, although Tolsons carried on in the tripe-dressing trade for many years in other parts of Leeds. The image below shows the Red Leopard, formerly the Jubilee, in The Headrow.

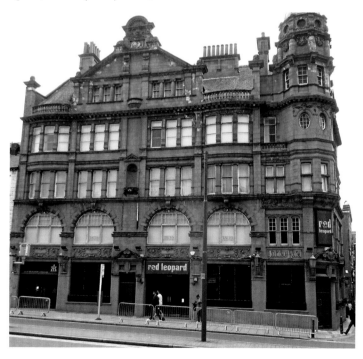

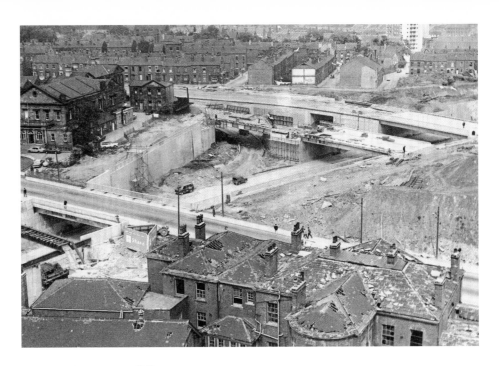

The Yorkshire Post Building

The *Yorkshire Post*, the inner ring road and the Leeds International Swimming Pool feature prominently in this aerial photograph. The lower photo shows the inner ring road under construction in 1966, with Woodhouse Lane and the old BBC studios on the left with Harewood Barracks. The buildings in the foreground were demolished to make way for what is now Leeds Beckett University.

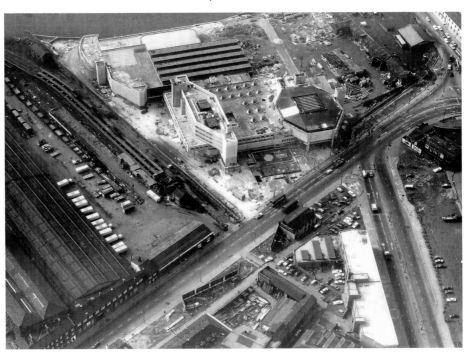

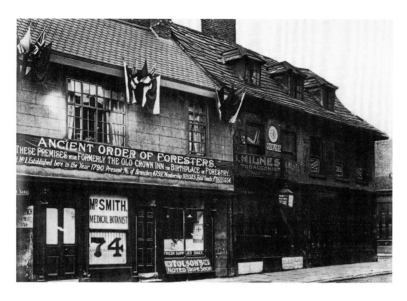

The Ancient Order of Foresters

Taken around 1907, this photograph shows the south side of Kirkgate from Old Crown Yard to Wharf Street with the Old Crown Inn, home of the Ancient Order of Foresters and shop premises for Mr Smith, medical botanist, and Tolson's noted tripe shop. It was demolished in 1935. The Ancient Order of Foresters was established here in 1790; it was one of many provident institutions in Leeds which included the Free Masons, the Druids, the Ancient Romans and the Odd Fellows to provide mutual aid in cases of sickness, death or infirmity. In 1837, nearly 300 people were signed up in Leeds and the surrounding area, insuring them against the workhouse. The striking gold letter box near the Town Hall marks the gold medal won by local Nicola Adams, flyweight boxer, at the 2012 London Olympics.

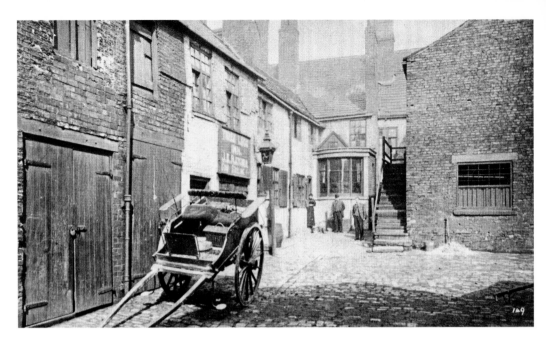

Three Legs Inn Yard

Off Lower Headrow around 1890, and named after the pub that is famous for its Edwardian glazed façade, it started life around 1743 and still serves today. The newer photograph taken on the steps of the art gallery shows a fascinating sculpture by John Latham.

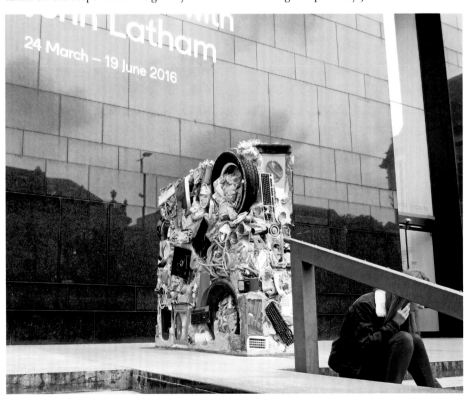

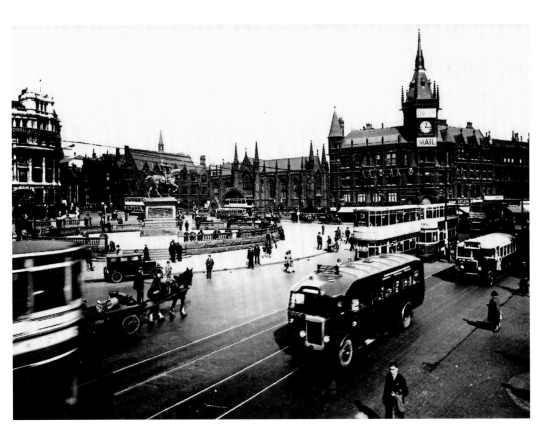

City Square in the 1930s
Buses are very much in evidence now in this early 1930s shot. The lower picture is the Black Prince getting himself together in City Square. The statue took seven years to complete and was cast in Belgium because it was too big for any British foundry. The Black Prince was brought to City Square by barge from Hull along the Aire and Calder Navigation and was unveiled on 16 September 1903. (Courtesy of Leodis; Leeds Library & Information Services)

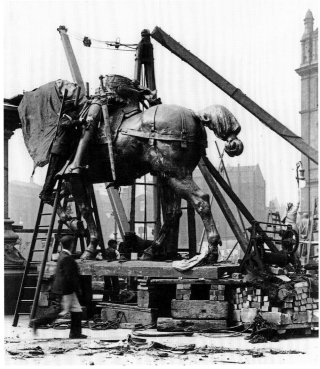

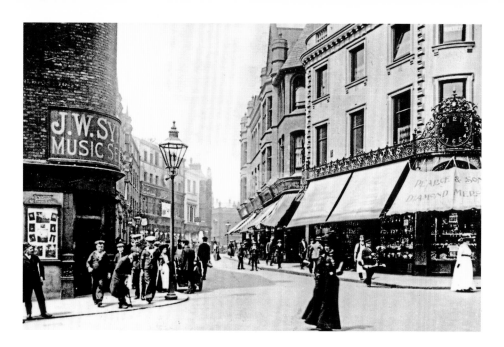

Bond Street

Bond Street in the 1910s with music shop J. W. Sykes on the right behind off-duty sailors. Other retailers here included florist Walter Allsop, costumer Madame Arthur and umbrella makers Phelan & Co. All were demolished in the 1920s. The Music Room in the Light on The Headrow is in the newer photo.

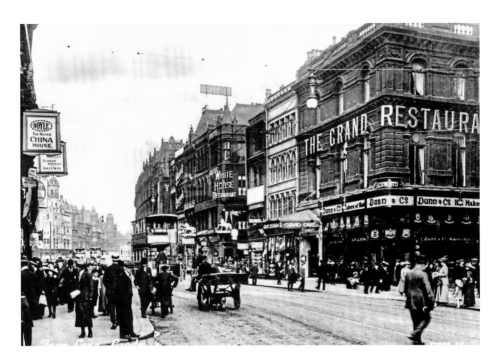

The Grand Restaurant and the White Horse Restaurant

The Grand Restaurant and Café, and the White Horse Restaurant in Boar Lane, looking toward the Corn Exchange. Before road widening took place in the late 1860s, Boar Lane only measured 20 feet across, so all of the south side was demolished and replaced with the buildings seen to the right here, with a new road width of 66 feet (20 metres). Fairburn's White Horse restaurant is on the right; it was one of five city centre restaurants owned and run by the Fairburn family – the first one opened in the 1880s. The White Horse opened in 1900 and was still run by a member of the Fairburn family when it closed in 1970.

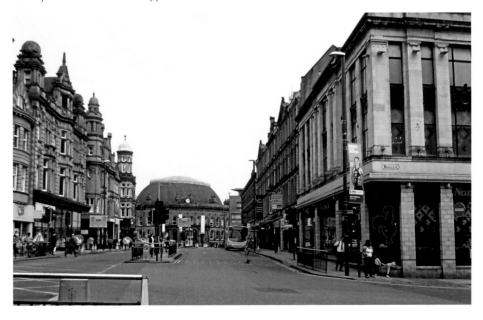

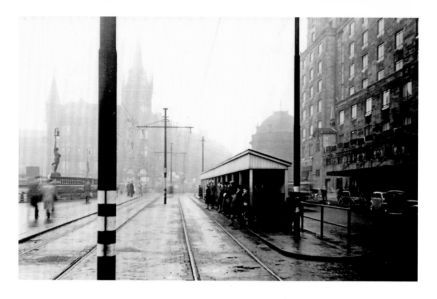

City Square

A desolate City Square in 1946 with the Leeds City Tramways shelter and the Queen's Hotel on the right. The square was officially opened on 16 September 1903. Apart from the old post office, there was the original Queen's Hotel on Wellington Street, which opened in 1863 and was later demolished to make way for the present 1936 hotel. The 186-room Park Plaza Hotel on the corner of Boar Lane and Park Row occupies Royal Exchange House. Today, the impressive building at No. 1 City Square is on the site of the 1901 Standard Life Assurance building which was replaced by the Norwich Union building in 1967. This was demolished in 1995. Down Infirmary Street leading off from the square, the post office building is on the left before you reach the former Yorkshire Penny Bank building with its distinctive tower. This occupies the site of the first infirmary from 1771, which was opened by the Duke of Devonshire on 17 August 1894 with a golden key.

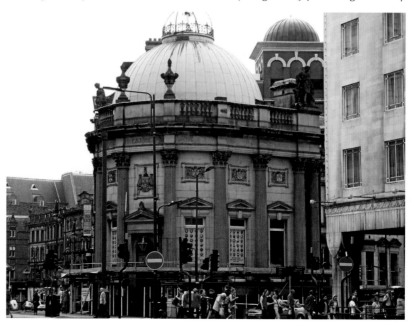

Bramley's Yard – 'Unhealthy Area'

Bramley's Yard in 1936 and behind the south side of the Lower Headrow is described as 'an unhealthy area'. On the right you can see the arm and hammer emblem of the Gold Beaters Guild, indicating where the shop of W. Barnes was situated. The yard also contains the staff and goods entrance of J. Lyons & Co.. The 1851 census reports fourteen households in the yard. Businesses operating from the yard included two tailors, a mangle woman, a rag merchant, a whitesmith, a beerhouse-keeper, an undertaker and the goldsmith. Three households had servants and several accommodated lodgers. In the new picture, we can see Time Ball Buildings at Nos 24–26 Briggate (*c.* 1820) – a rare surviving example of elaborate and ornate Victorian-Edwardian shop innovation and design. The premises had a number of occupants over the years – distiller, saddler and trunk maker, a barber, perfumer and a stationer – through the nineteenth century until 1871. In 1872 J. Dyson, watchmaker, was at No. 26 and by 1872 the company occupied the whole building.

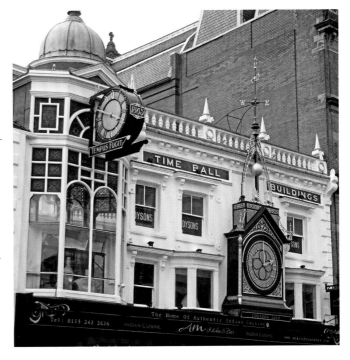

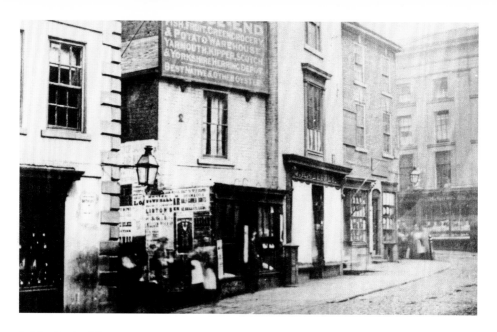

Bridge End, 1869

Taken in 1869 by A. Macaulay and replicated for Leeds City Engineers in 1909, this picture shows the part of Bridge End that is near to the old Leeds Bridge around the corner on the right. On the near left is the Fountain Inn (No. 27). At No. 28 is the Bridge End Fish, Fruit, Greengrocery & Potato Warehouse, and the Yarmouth Kipper, Scotch and Yorkshire Herring Depot which provides 'the best native and other oysters'. In 1867, it was run by Charles Millington. Poster advertisements include one for half-guinea boots from Hyam & Co. of No. 42 Briggate. At No. 29 is wholesale linen draper, John Myers Gardner; at No. 30 is hairdresser David Holroyd. At the end of the row is No. 31, Frederick Boocock, cork cutter. These businesses were all shut down at the end of 1869 and demolished – the same fate as the old bridge.

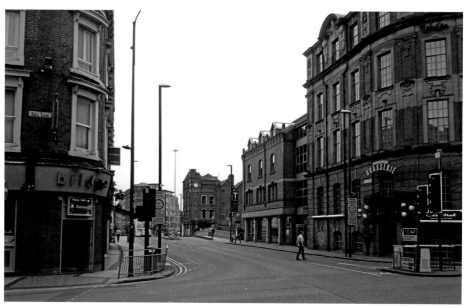

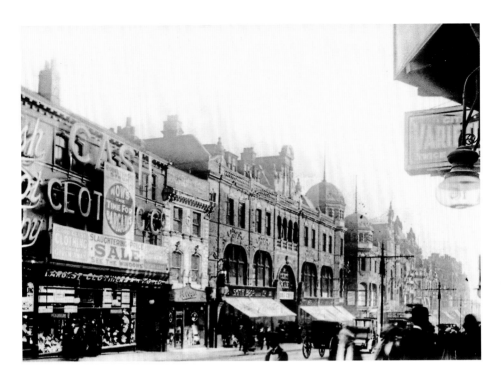

1900s Briggate

A view down Briggate with bargain shops on the left. The Cash Clothing Co. is running a 'slaughtering price sale'. The County Arcade is further down with a sign pointing to City Varieties on the right.

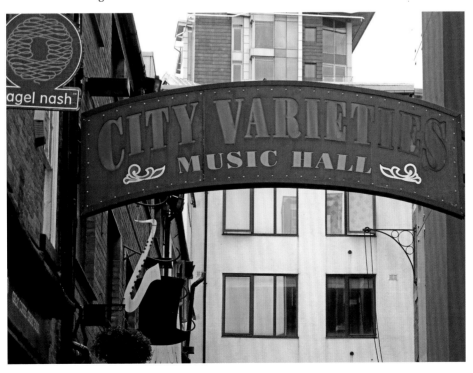

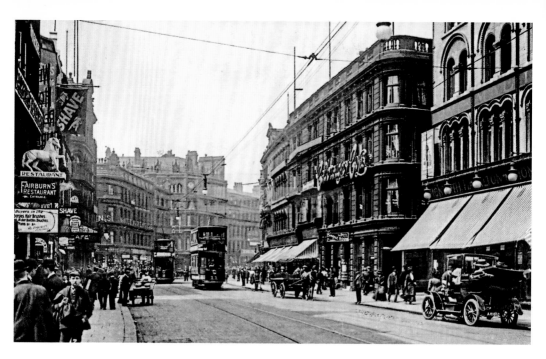

1910s Boar Lane
Boar Lane in the 1910s with motorcar, horse and cart, tram and handcart.

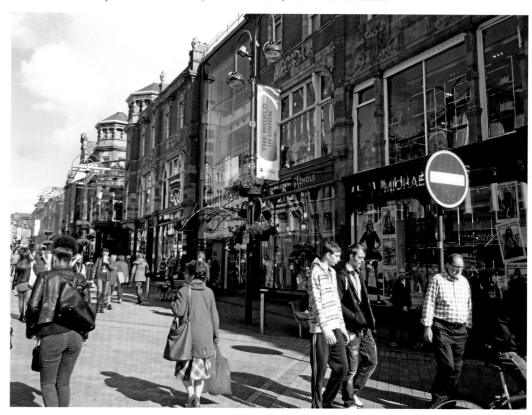

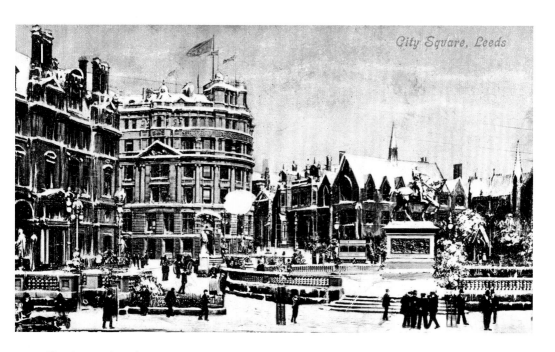

City Square in Winter Snow

A wintry scene in which the Black Prince temporarily becomes the 'White Prince'. There are also statues of local heroes: Joseph Priestley, the founding father of modern chemistry; John Harrison, early woollen-cloth merchant; Leeds benefactor James Watt of steam engine fame; and Dr Walter Farquhar Hook, the vicar behind the establishment of twenty-one churches in Leeds, as well as of eight nymphs and some elegant light standards.

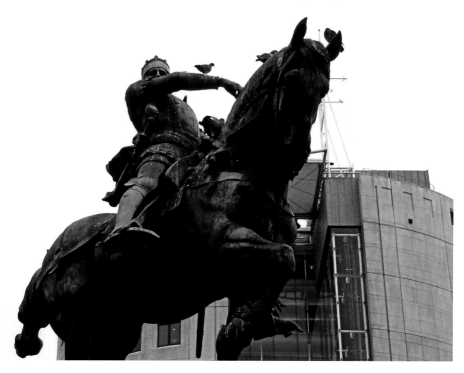

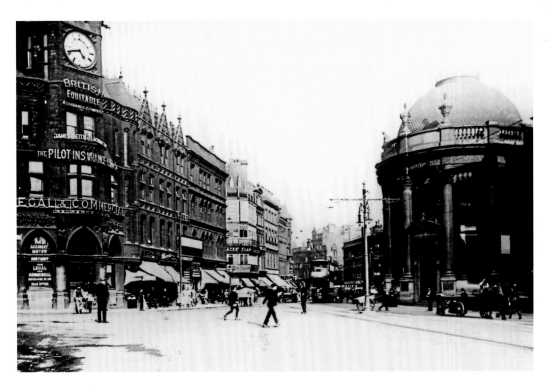

Boar Lane in the 1900s
Insurance companies abound.

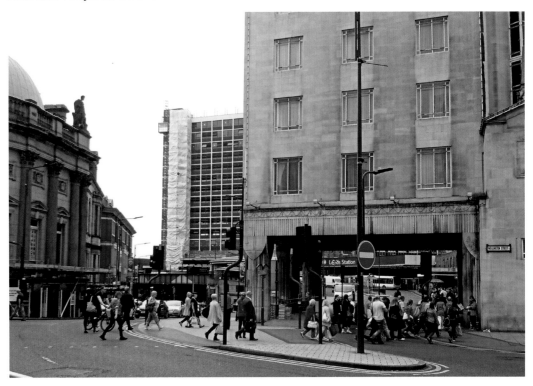

Briggate

A wonderful view of the west side of Briggate around 1890 looking towards The Headrow. The birthplace of Marks & Spencer is commemorated in the newer image. The business started out as a Penny Bazaar at Kirkgate Market in 1884. In March 2013, Marks & Spencer opened a stall at Kirkgate Market in the same place that Michael Marks opened the first Penny Bazaar stall in 1884. The Marks & Spencer heritage stall and coffee shop is beside the famous clock named after the company in the 1904 Kirkgate Market building, signifying the starting point of the Marks & Spencer Heritage Trail. In 2012, the magnificent Marks & Spencer Company Archive relocated to the Michael Marks Building, Western Campus, University of Leeds.

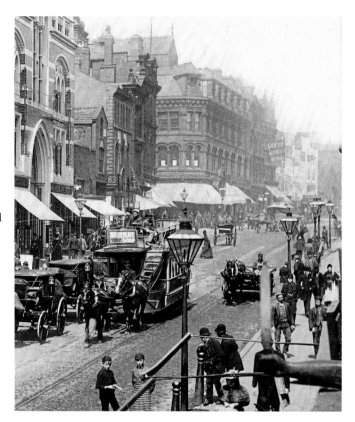

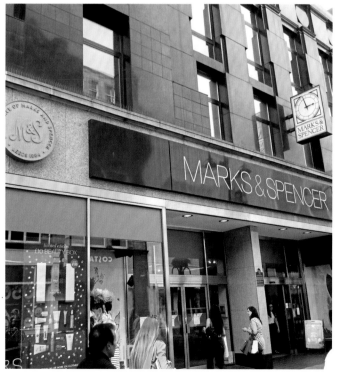

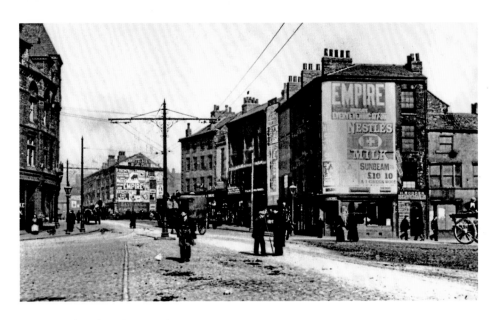

Bridge End in the Nineteenth Century

Looking north onto Briggate, businesses here in 1867 included F. Boocock, cork cutter at No. 31 Bridge End, a bookseller's run by Thomas Child at No. 32, and Robert Cross, confectioner, at No. 33. The Empire presented such acts as Anna Swan from Nova Scotia, often paired with Tom Thumb, a dwarf. Anna was born in 1846 and grew to nearly 8 feet tall, touring across America and England. While in England, she met and married Kentucky-born Martin Van Buren Bates who also had gigantism. Anna died of tuberculosis in 1888. There was also conjoined Thai-American twins, Chang and Eng Bunker, farmers in North Carolina, who toured the world. They both died in 1874, within three hours of each other, and were said to be the inspiration for the term 'Siamese twins'.

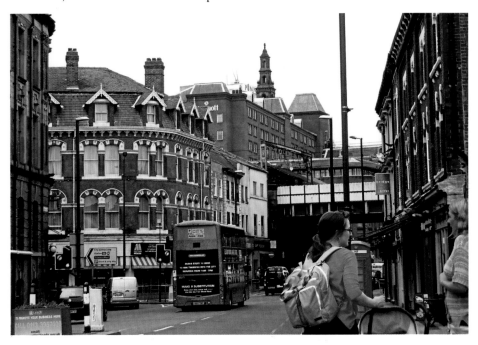

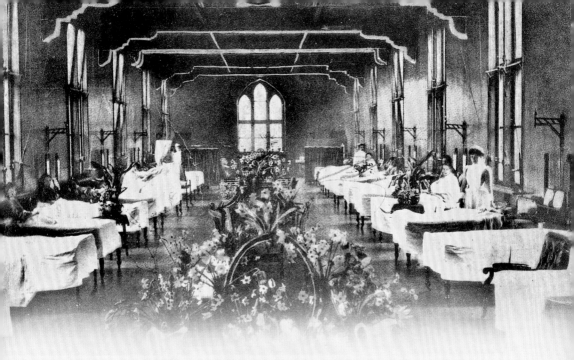

CHAPTER 4

Health & Education

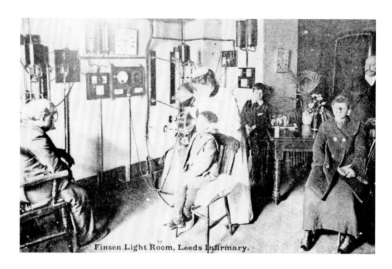

Finsen Light Room, Leeds Infirmary.

The General Infirmary

The General Infirmary at Leeds (its old official name) dates back to June 1767 when an infirmary 'for the relief of the sick and hurt poor within this parish' was set up in a private house in Kirkgate. Four years later, the General Infirmary's first purpose-built building opened near City Square in Infirmary Street on the site of the former Yorkshire Bank; the five founding physicians were all graduates of the University of Edinburgh Medical School. The infirmary has continued to expand ever since, resulting in the move to the site on Great George Street in 1869, magnificent buildings designed by Sir George Gilbert Scott. The Finsen Light Room at Leeds General Infirmary was established in 1901 when a dermatology department was completed. The Finsen lamp was developed by Danish physician Niels Ryberg Finsen who discovered the therapeutic effects of ultraviolet rays for certain conditions of the skin, in particular lupus vulgaris, a tuberculous skin disease. The treatment was successful and, by 1903, three lamps were in use with sixty patients a day being treated.

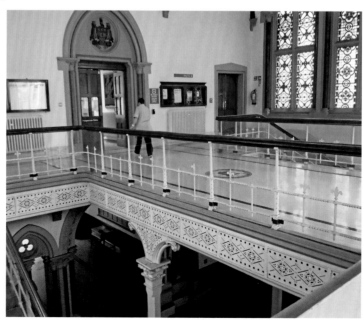

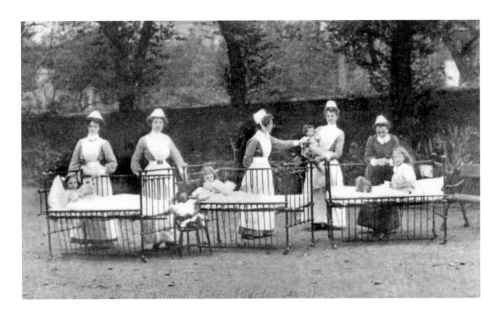

Leeds Hospital for Women and Children

Founded in 1853, the children's department was later moved to Leeds General Infirmary. Here, in 1910, they are exposed to bracing fresh air – a cure for all manner of ills. The hospital was initially in East Parade but moved to Coventry Place in 1855, and later to Roundhay Hall. The image on page 45 shows a blossoming No. 9 ward at Leeds Infirmary around 1908. The magnificent interior of the old part of the Leeds General Infirmary is shown on pages 45–47.

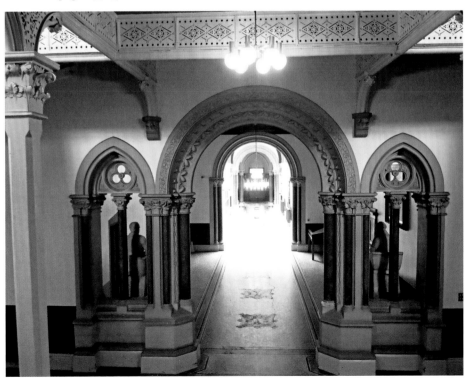

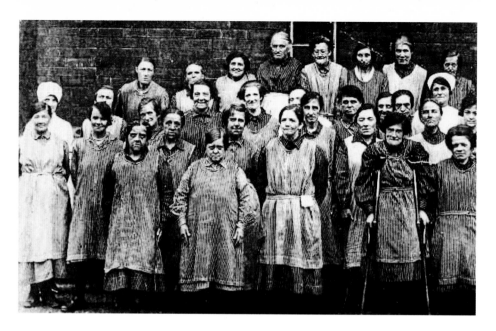

Leeds Workhouse

In theory, the workhouse was intended to provide care and comfort to the most needy and shield them from the worst depredations of life. The reality was often very different. These disturbing images show Leeds workhouse's female inmates and Leeds workhouse from the cemetery – the last resting place for many paupers. The building, now housing the Thackray Medical Museum, opened in 1861 as the first purpose-built Leeds Union Workhouse to accommodate 784 paupers; over time new buildings were added to the workhouse including a separate infirmary. In 1848, the Leeds Guardians built the Moral and Industrial Training Schools on the north side of Beckett Street. During the First World War, it was called the East Leeds War Hospital, caring for armed services personnel. In 1925, the Leeds Union Workhouse infirmary was repurposed and renamed St James's Hospital. (Courtesy of St James Hospital, Leeds)

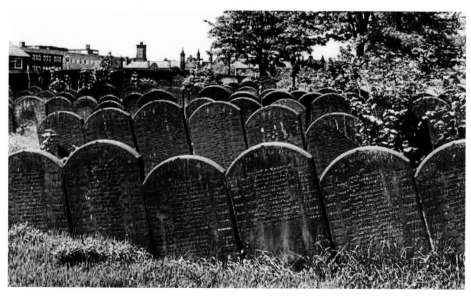

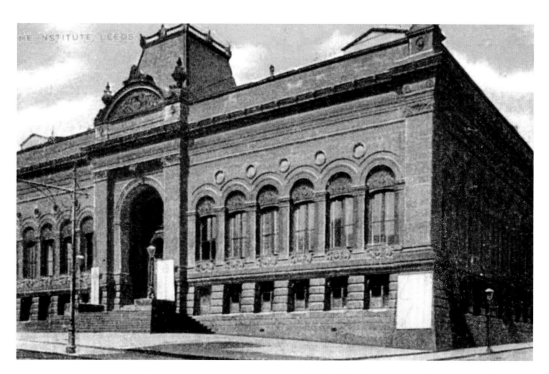

The Mechanics' Institute

Leeds Mechanics' Institute (1824) was built
by Cuthbert Broderick. The objective of
the Mechanics' Institute was to maintain a
technical education for the working man and
for professionals to 'address societal needs by
incorporating fundamental scientific thinking
and research into engineering solutions'. They
effectively transformed science and technology
education for the man in the street. A number
have become cutting-edge universities or
similar centres of excellence. Leeds is a case in
point. In 1846, the Leeds Mechanics' Institute
was already offering drawing classes when it
merged with the Literary Institute, creating
Leeds School of Art. In 1868, Leeds Mechanics
Institute became the Leeds Institute of Science,
Art, and Literature. In 1903, it moved to the
Vernon Street building, whose radical design
reflected the Art and Crafts movement.
Henry Moore and Barbara Hepworth are
among the alumni, enrolling in 1919 and 1920
respectively. When the Mechanics' Institute
stopped educating, it became a concert hall,
known as the Civic Theatre, and later, the City
Museum. The new photograph depicts a statue
of Circe, the enchantress from Homer's *Odyssey*
who detained Odysseus, seduced him and
turned his men into swine.

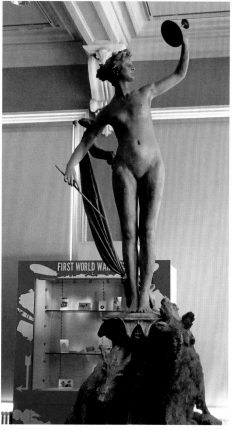

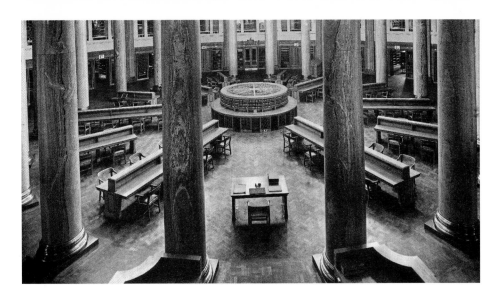

Brotherton Library, Leeds University

The Brotherton Library in the Parkinson Building is a Grade II-listed Beaux Arts building with art deco fittings, completed in 1936. It is named after Edward Brotherton, who bequeathed £100,000 as funding for the University of Leeds's first purpose-built library in 1927. While the university was still Leeds College, it stocked all of the university's books and manuscripts, except the books housed in the separate Medical Library and Clothworkers' Textile Library. The magnificent Reading Room, pictured here, has 6,000 shelves holding 200,000 volumes. It is 20 feet larger in diameter than the British Museum Reading Room and there are twenty green Scandinavian marble pillars.

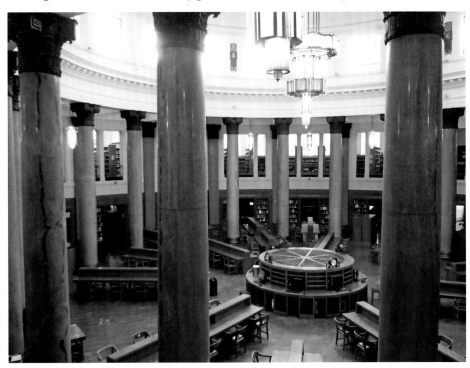

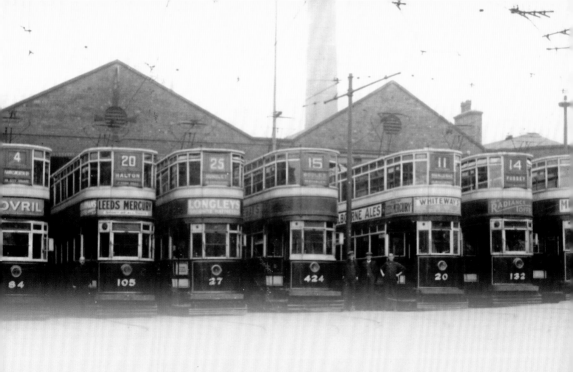

CHAPTER 5

Transport

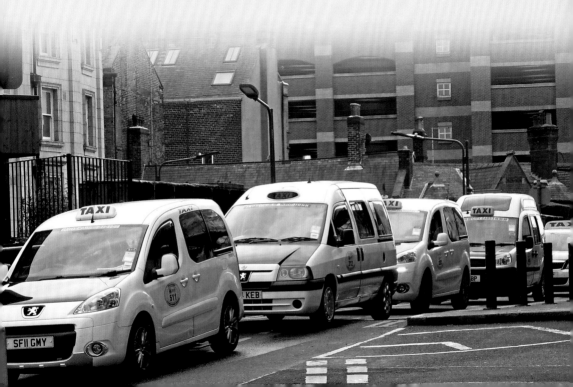

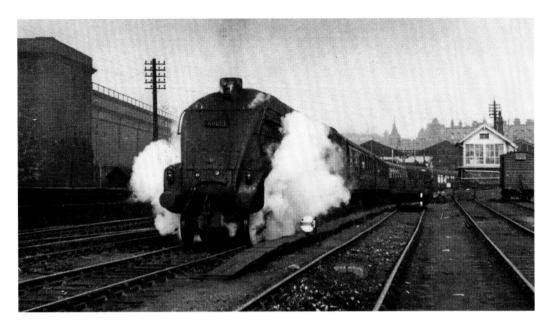

60013 Dominion of New Zealand

Speeding out of Leeds, hauling the *White Rose Express*. The newer image is a rusting hulk of a train at Leeds Industrial Museum at Armley. The images on page 51 show a line of trams at the depot displaying an interesting range of contemporary advertisements and a line of uniform taxis at Leeds station in 2016.

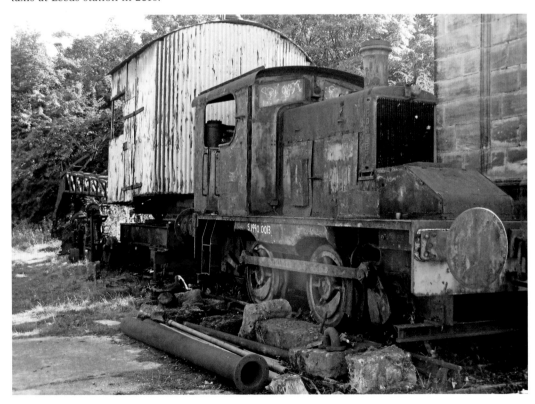

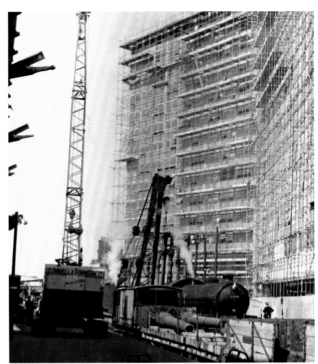

Leeds Station

July 1963 and Leeds station is being rebuilt. The City House office block is on the right, under construction. In June 2016, there is yet more building.

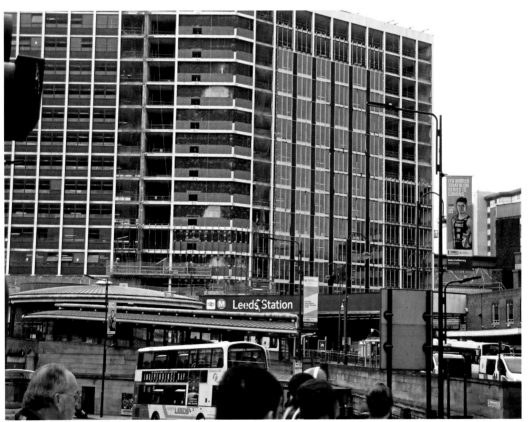

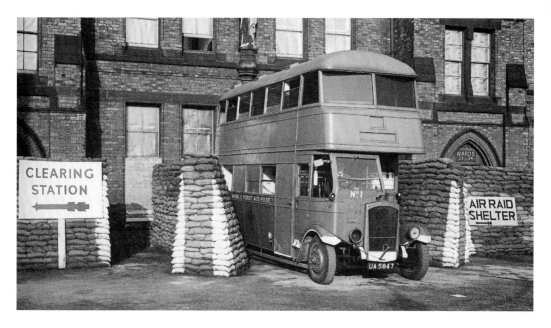

A Mobile First Aid Post

Pictured in 1939, the first aid post is housed within one of four converted buses behind Leeds General Infirmary. They were crewed by eight full-time male staff and forty-three full-time female staff. Ambulances queue up for a call at the Leeds General Infirmary in 2016.

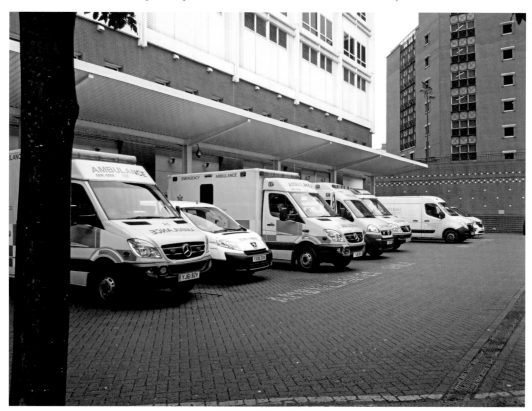

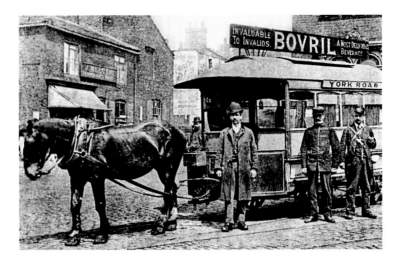

Horse-Drawn Tram

This sixteen-seater Milnes Tramcar No. 1 is at the York Road terminus. Leeds Corporation Tramways transport network opened on 29 October 1891 with horse-drawn and steam trams; by 1901, these had been replaced by electric-powered trams.

Bovril is made into a drink by adding hot water or milk and is used as a flavouring for soups, stews or porridge, or spread on bread and toast. The first part of the name comes from the Latin *bos, bovis* meaning ox; the -vril suffix derives from Bulwer-Lytton's novel, *The Coming Race* (1870), about a superior race of people, the Vril-ya, who get their powers from an electromagnetic element called 'Vril' – thus, Bovril is 'ox power'. The newer photograph shows a display of advertisements for famous nineteenth-century Leeds companies at the City Museum.

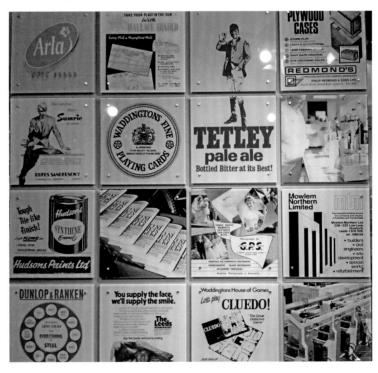

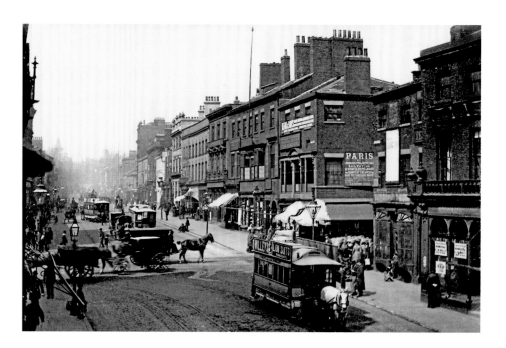

Horse-Drawn Trams on Briggate

This photograph was taken in the late 1890s and shows a number of horse-drawn trams, horses and carts, and horses and traps. Note the advert for train trips to Paris via London. The blue plaque at Queen's Court, off Briggate, epitomises and encapsulates, in a few words, the essence of nineteenth-century Leeds and its growth as a major European textile manufacturing centre.

QUEENS COURT

This historic courtyard occupies one of the 60 burgage plots which abutted Briggate in the Middle Ages. It is fronted by an eight-bayed woollen cloth merchant's house (built c.1714) and contains the merchant's cloth finishing shops and warehouses.

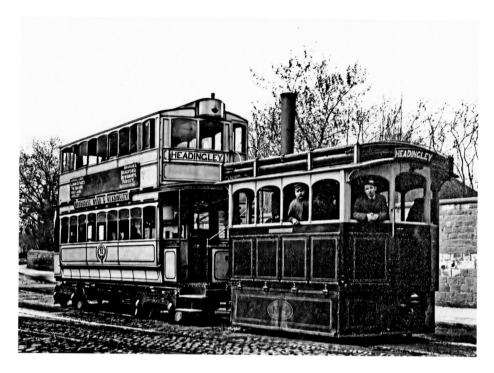

Leeds Steam Trams

The top image shows a Kitson steam tram bound for Headingley. They were first used in Leeds in May 1891 on the Sheepscar–Oakwood route. The lower image is of a No. 12 engine with a Milnes carriage No. 26 behind; Thomas Green & Son Ltd, based at Smithfield, manufactured tram engines for the Leeds Tramway Company. The tram is about to make a return journey from Wortley to Reginald Terrace.

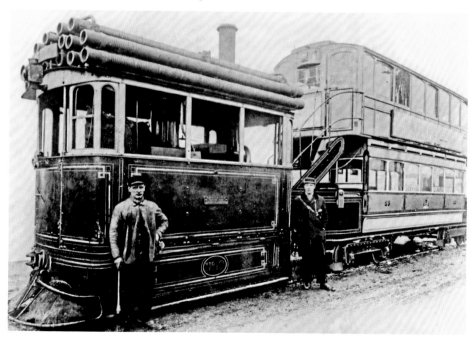

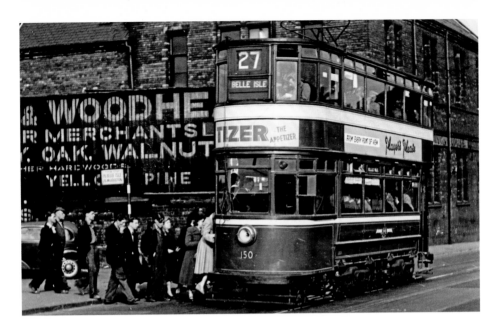

The Tram to Belle Isle

Belle Isle Circus is an expanse of public open land in the middle of a traffic roundabout; originally it was the site of a tram terminus. The lower image shows Leeds Experimental Trolleybus No. 503. Trolleybuses ran on normal roads instead of tramlines and were used in Leeds on more rural routes unsuitable for trams, such as to Farnley and Drighlington, and from Guiseley to Otley. The first trolleybuses ran to Farnley in 1911 and to Otley in 1915, but they were not successful and buses eventually took over, with the last trolleybus running to Otley on 26 July 1928.

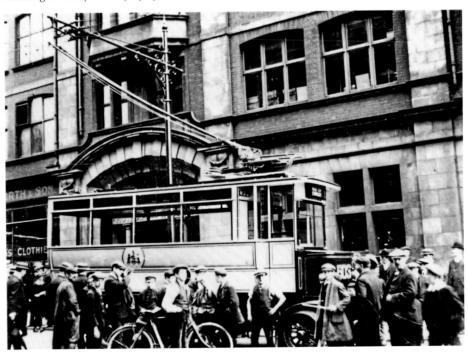

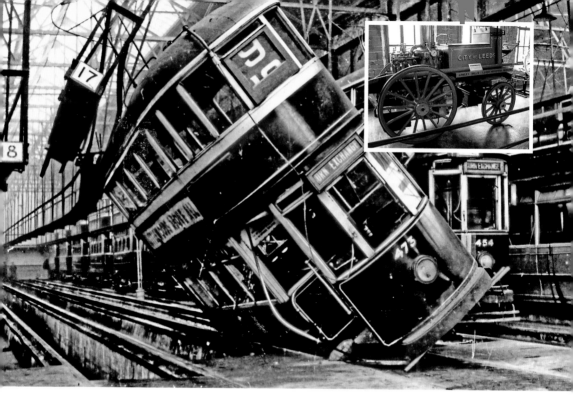

Tilting Tram No. 473

On 22 September 1949, Tram 473 to the Corn Exchange got into a spot of bother in Swinegate depot when it derailed during a routine tilt test and fell into a pit, ending up at an angle of around 45 degrees. The tram was originally from Hull; it never ran in service again and was burned at Low Fields Road Yard on 16 May 1950. The new image shows a horse-drawn fire engine at Leeds Industrial Museum. (Courtesy of Tramway Museum Society)

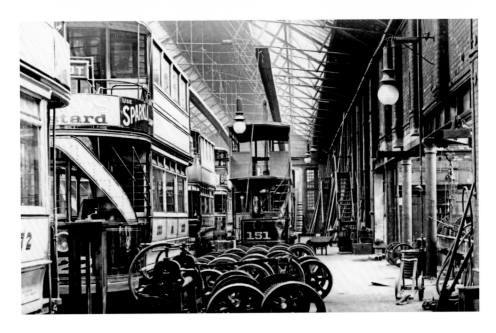

In the Depot

Leeds trams in the depot for repair. The earliest trams were single-decker but later ones were double-deckers. During most of the twentieth century, Leeds Tramway Company used both double-decker bus-style and balloon trams. The system of power collection from the overhead wiring was unusual in that it used pantographs instead of poles, obviating the need to turn the pole round at every terminus. The lower image shows wheels about to be fitted to a locomotive on a wheel drop at Leeds engine shed on 16 July 1920. Engine sheds were used to store and service locomotives as well as make repairs, although large repairs were usually carried out at railway works. Steam locomotive wheels have been made from steel since 1870 and were previously made from wrought iron. Locomotive wheels often had spokes to make them lighter.

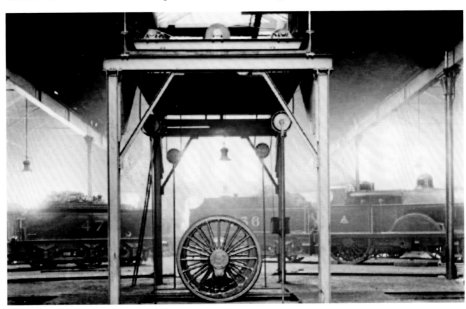

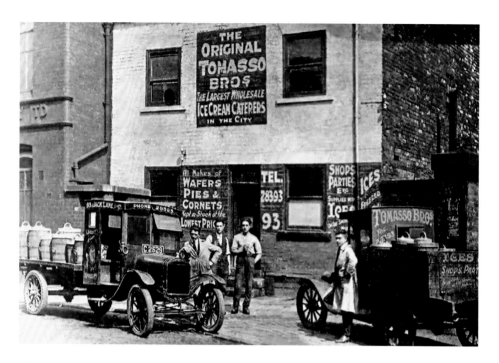

The Last Word in Ice Cream

This is the notice in the *London Gazette* on 29 November 1929 for the winding up of the Tomasso Bros business:

> TOMASSO, John, residing at 143, Water-lane, and TOMASSO, James, residing at 45, Telford-terrace, and lately carrying on business together in co-partnership with Stephen Tomasso, under the style or firm of "Tomasso Brothers," at 93, Jack-lane, all in the city of Leeds, as ICE CREAM MANUFACTURERS. Court—LEEDS. No. of Matter—66 of 1929. Date of Order—Nov. 14, 1929. Date of Filing Petition—Oct. 10, 1929.

A delivery van for Sharp's basket and skep manufacturers is in the lower image.

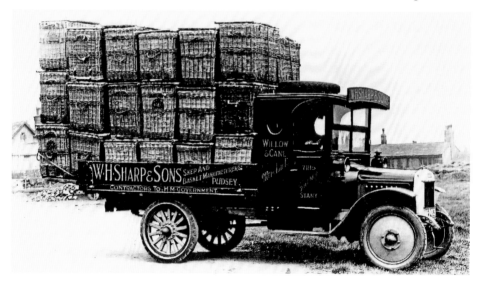

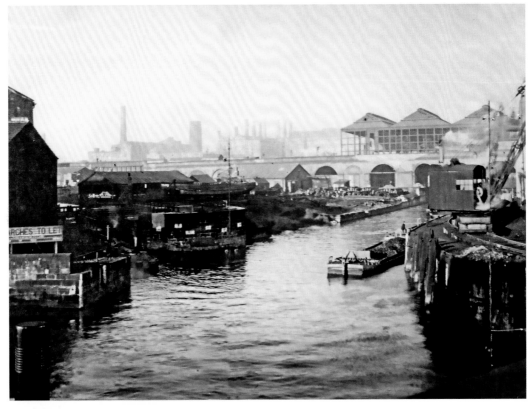

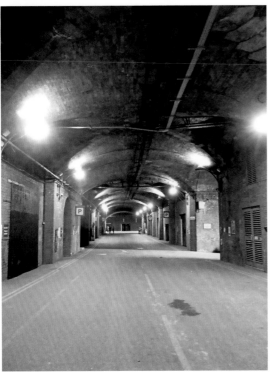

The Canal and the Dark Arches

Arches to let in industrial Leeds. Leeds station was built over a series of arches spanning the Aire, Neville Street and Swinegate – the Dark Arches can still be seen today. More than 18 million bricks were used in their construction, a record at the time in what was a series of independent viaducts two or four tracks wide. The station is at the terminus of the Leeds and Liverpool Canal, but as it is raised high above ground level you can access the Dark Arches from the towpath. The Dark Arches is now part of Granary Wharf, with shops, restaurants, markets and street entertainers.

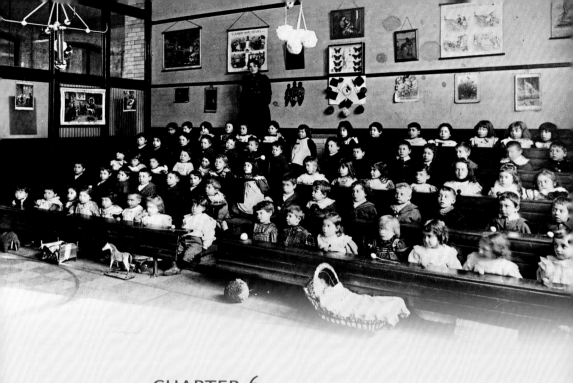

CHAPTER 6

Work

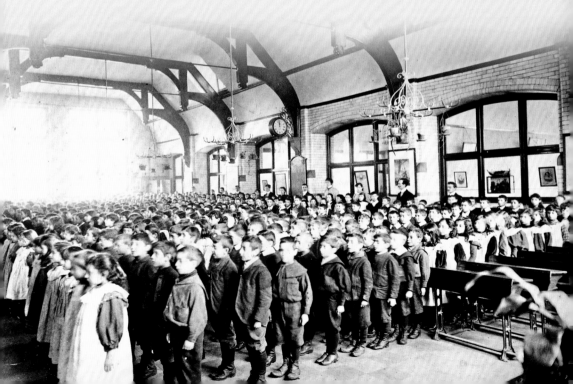

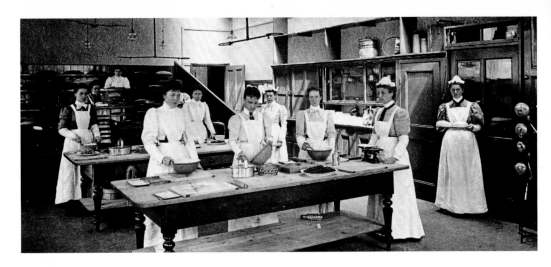

The Cookery Class

A cookery class at the Leeds School of Cookery and Domestic Economy in Albion Street, known as the 'Pud School'. The school was founded by the Yorkshire Ladies' Council of Education in 1874 and was taken over in 1907 by the Leeds Education Committee, becoming part of the Yorkshire Training College of Housecraft; they moved to Vernon Road in 1933 and it is now part of Leeds Beckett University. The new photograph captures the wonderful Rose Bowl Building. The images on page 63 show children working hard with their teachers and children standing to attention in lines for an assembly in the Central Hall at Darley Street School; teachers are at the back and an infant class is present. (Courtesy of Leodis; Leeds Library & Information Services)

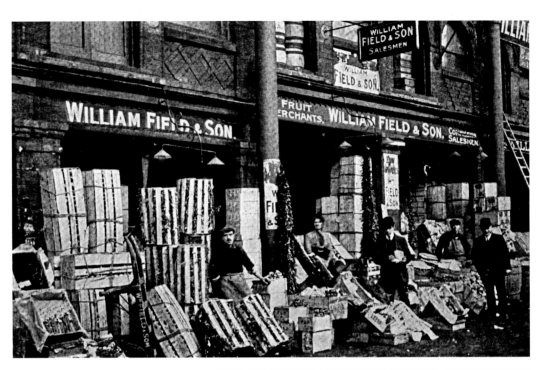

Fruit Merchants William Field
The famous Marks & Spencer clock in Leeds Kirkgate Market, marking the location of the first Marks & Spencer penny stall.

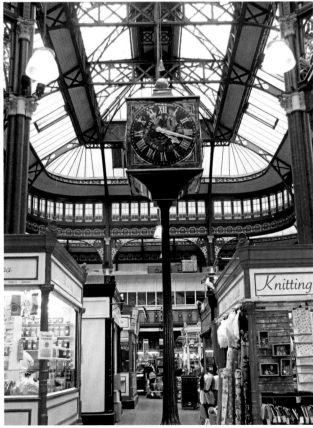

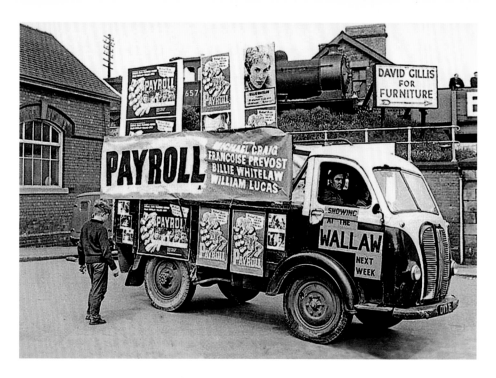

Payroll at the Wallaw

Payroll (1961) is a classic British crime thriller starring Michael Craig and Françoise Prévost about a gang of crooks who stage a robbery that goes badly wrong. Much of it is set in Newcastle and Gateshead. Modern movie advertising is shown here on a bus in 2016.

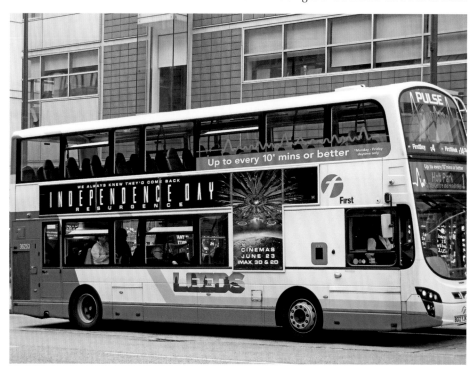

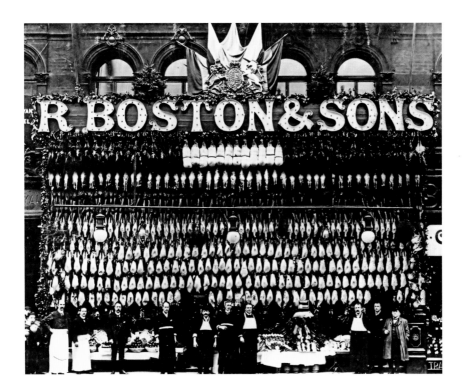

R. Boston & Sons

R. Boston & Sons in Boar Lane were one of Leeds's top-end game, fruit and fish stores. Waddington's 1894 *Guide to Leeds* tells us that Boston's provided fifty types of fish including oysters, every imaginable kind of bird, thirty-six different types of vegetable and 100 fruits. Richard Boston (1843–1908) was a major Leeds benefactor. Fish retailing today takes place in Kirkgate Markets.

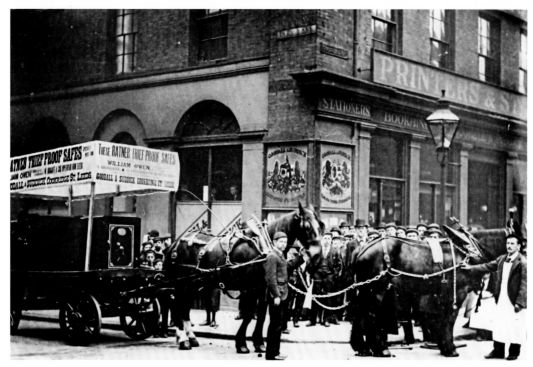

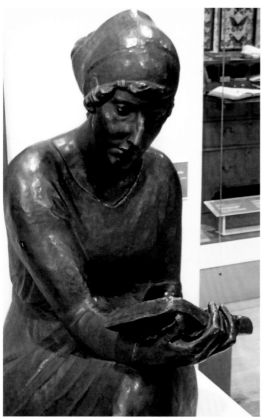

Goodall & Suddick

In Cookridge Street, stationers, bookbinders and the proud agents for 'Ratner Thief Proof Safes'. The modern image is of a bronze, in the City Museum, of Dorothy Una Ratcliffe (1887–1967), niece of Lord Brotherton and writer of poetry in the Yorkshire dialect. She is one of the celebrated (but often overlooked) female poets of the First World War, having helped Lord Brotherton equip the Leeds Old Pals Regiment. She also assisted with Belgian refugees.

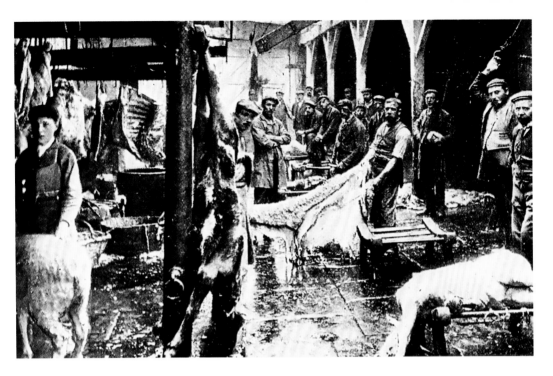

Leadenhall Slaughterhouse

On Leadenhall Street looking towards Vicar Lane and with a reputation for being 'unhealthy', Leadenhall Wholesale Carcase Market was replaced by Kirkgate Abattoir, New York Street, in 1831. This was then replaced in 1966 by the Pontefract Lane Abattoir. The image below shows meat retailing today in Kirkgate Markets.

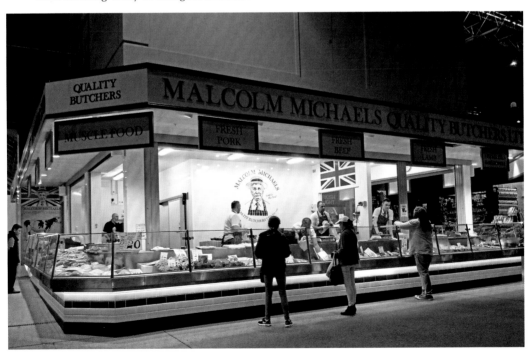

Shoeing a Tetley's Horse

A farrier, busy shoeing a dray horse at the Tetley Brewery. Shire shoes last for a month, or six weeks at best. Tetley's Brewery was founded in 1822 by Joshua Tetley. By 1860, it was the largest brewery in the North of England. The art deco Tetley headquarters building was built in 1931. During the 1960s, the brewery employed over 1,000 workers and, in the 1970s, half of Leeds's pubs were owned by Tetley. The final brew was on 22 February 2011. Production of some of the beers was transferred to Cameron's in Hartlepool. In November 2013, the art deco main office building was reopened as The Tetley, a contemporary art and learning centre.

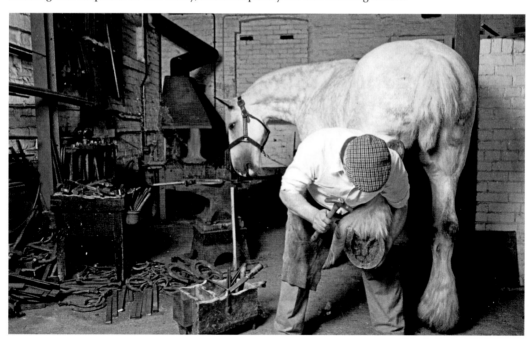

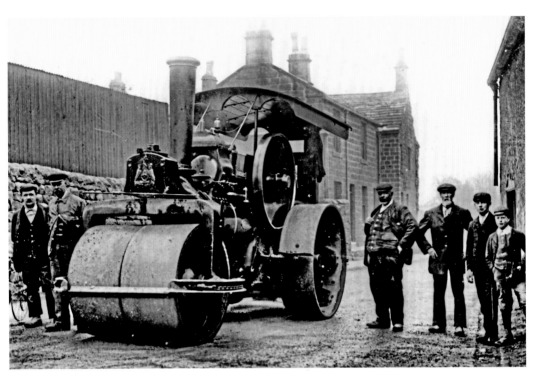

The Horsforth Steamroller

Horsforth had the largest population of any village in the UK during the latter half of the nineteenth century. During the Second World War, the people of Horsforth raised all of the £241,000 required to build the corvette *HMS Aubretia*. In 2000, US President Bill Clinton acknowledged Horsforth's contribution to the war effort in a letter sent to MP Paul Truswell. The letter is now in the local museum. A steamroller in Leeds Industrial Museum is the new photograph.

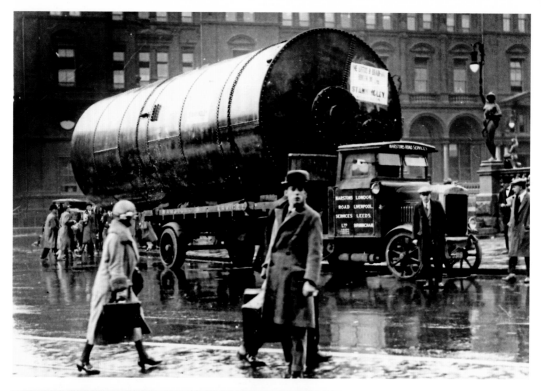

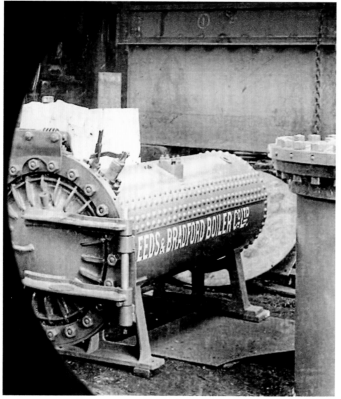

Big Boiler in the City

A Leeds & Bradford Boiler Co. (Stanningley) wagon negotiating City Square in the 1920s. The Leeds & Bradford Boiler Co. was founded over 130 years ago and has been run by five generations of the same family. Today, the company has a global reputation as a leading supplier of autoclave solutions and precision engineering.

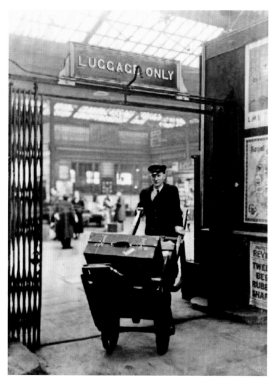

Porter at Leeds Railway Station, 1930s
Between 1866 and 1869, the North Eastern
Railway constructed the new station
to connect lines from Bradford and
the west and lines to York, Selby and the
north-east.

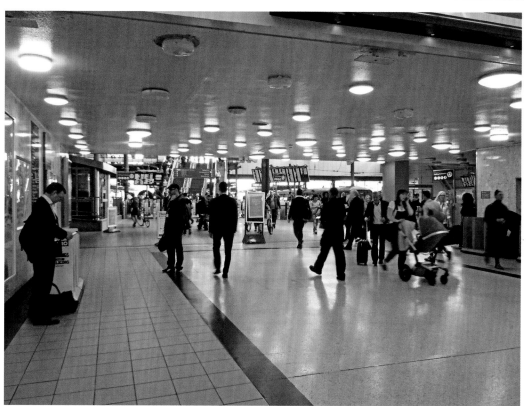

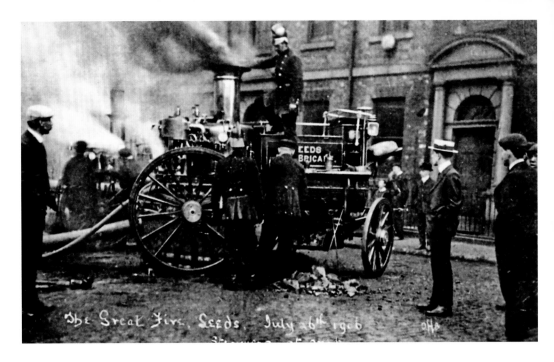

The Great Fire in Leeds, 1906

Firefighters in action at the Great Fire, 8 August 1906. This major event took place at No. 25 Wellington Street, at the junction with Thirsk Row, in a warehouse owned by Hepworth & Son Ltd (although some maintain it started in the premises of Hotham & Whiting). The fire leaped over Thirsk Row to attack the Great Northern Hotel. Three firemen were injured. The warehouse dated from 1881 and was totally rebuilt; it was occupied by Hepworths until the 1920s. In 2011, it was taken over by Sanderson Weatherall, chartered surveyors. The firefighters are using a steam-operated pump.

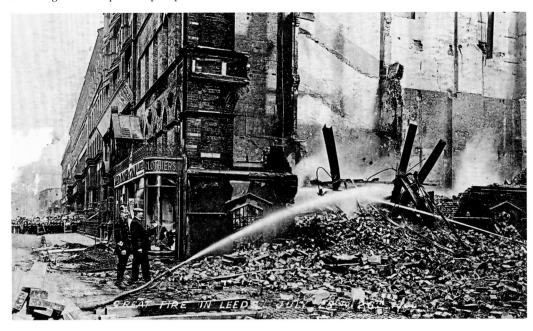

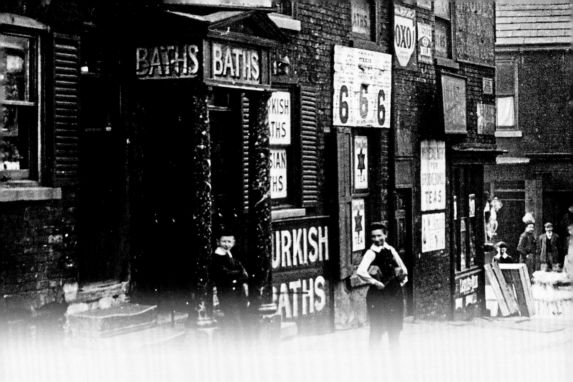

CHAPTER 7

Pubs, Leisure & Entertainment

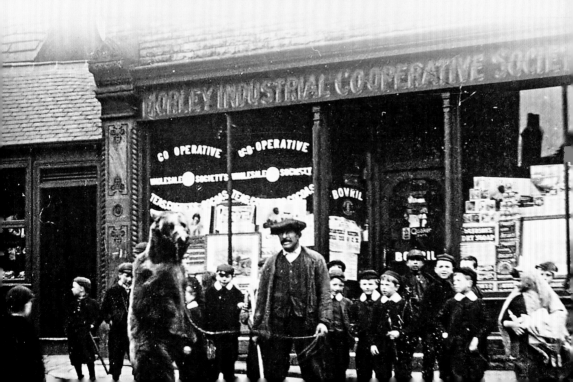

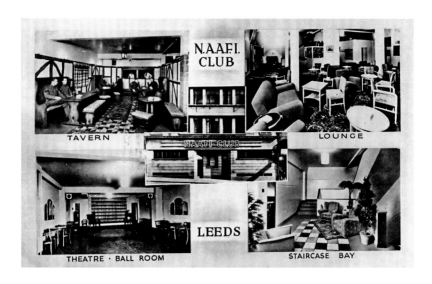

The NAAFI Club and St Peter's Baths

Four pictures promoting Leeds Navy, Army and Air Force Institutes Club, on the corner of Albion Street and Albion Square; it later became the YMCA. Since 1808, Commercial Street has been the home of the Leeds Library, pictured here in 2016 in its Greek Revival splendour. Leeds Library is the oldest surviving subscription library in the UK, founded in 1768; the first secretary was Joseph Priestley. The library has over 800 members who pay an annual subscription and has a stock of over 140,000 titles. The image on page 75 shows the Turkish-Russian baths in 1890. In 1858, two members of the Manchester Foreign Affairs Committee opened the Turkish bath in St Peter's Square, one of the first Victorian Turkish baths in England. The lower image shows a dancing bear holding court outside the Church Street branch of Morley Co-operative around 1902.

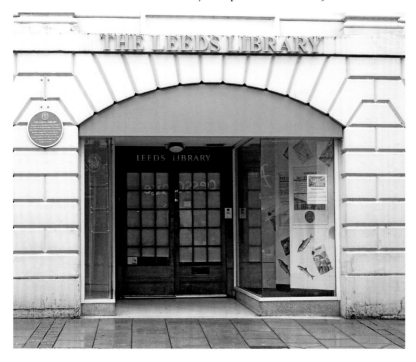

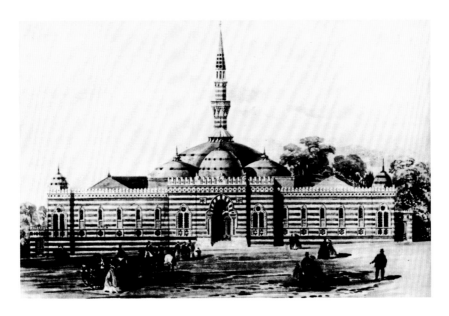

The Oriental and General Baths

This splendid, exotic building was built in 1866 in Cookridge Street to the design of Cuthbert Broderick. It was altered in 1882 and later demolished in 1969 following closure in 1965. The image is from the architect's watercolour drawing. Exoticism is also plentiful at Temple Works, a structure based on the temple at Antaeopolis and the Temple of Horus at Edfu, with a chimney in the shape of an obelisk; the factory building was modelled on the Typhonium at Dendera. Sheep grazed on the roof, not just as a gimmick but to retain humidity in the flax mill to prevent the linen thread from becoming dried out and unworkable. Sheep, of course, are not very good at climbing ladders or stairs so, to get them onto the roof and down again, the hydraulic lift was invented.

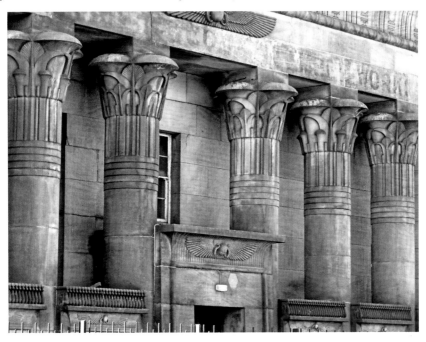

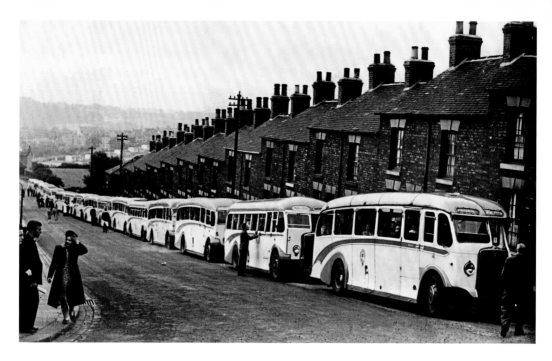

Wallace Arnold Coaches
Coaches are all set to take members of a number of working men's clubs on a day out in the 1950s. Their bus station was situated on The Calls.

Leeds - the home of Wallace Arnold since 1926.

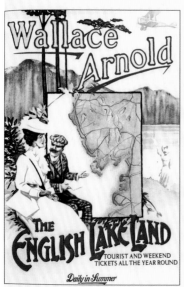

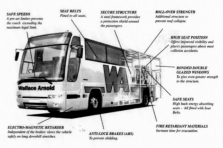

From 1926 to the present day - From charabancs for country trips at weekends to the most modern, safety conscious coach holiday fleet in Europe supported by an innovative range

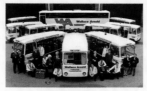

of unrivalled customer care services, the latest of which is our total luggage handling service.

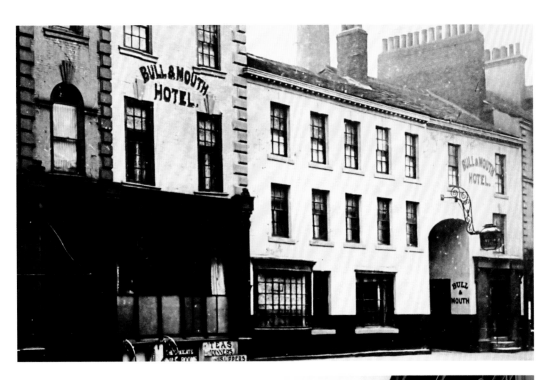

The Bull and Mouth Hotel

Originally the Red Bear at No. 138 Briggate, between Duncan Street and Kirkgate, it is one of Leeds's oldest hostelries. It was once a depot for heavy baggage wagons and became a coaching inn in 1800. Soon one of the busiest inns in Leeds, it had standing room for thirty horses in the cellar stables. The Loyal Duncan was the first coach to run from here and the True Briton left from here every morning at 10 a.m. for Manchester, arriving at 6.30 p.m. In 1903, it was renamed the Grand Central Hotel; in 1921 the name was changed again to the Victory Hotel – it closed in 1939. The original name, as with the coaching house in London's Aldersgate Street, derives from 'Boulogne Mouth', a reference to the town and harbour of Boulogne, as besieged by Henry VIII. The modern image shows the dramatic masks of tragedy and comedy on the sign for the Scarbrough Hotel in Bishopgate Street. The masks were first seen when Henry Scarbrough took over the property in 1826 as the Kings Arms. In the late 1890s, Fred Wood established The Scarbrough Hotel pub, organising talent nights, and any act showing promise was put on at his City Varieties.

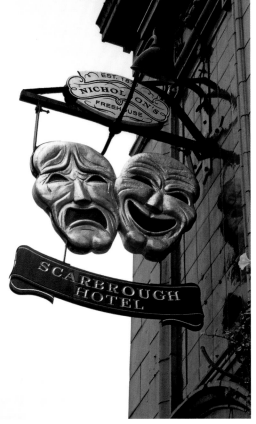

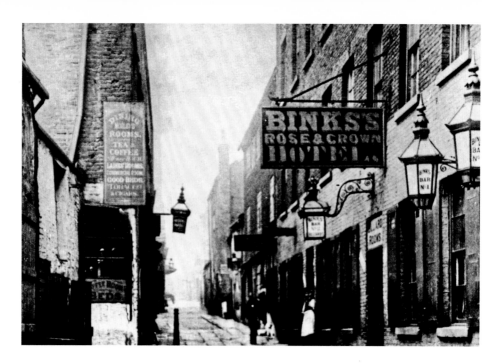

Binks's Hotel

Or the Rose & Crown Hotel, a coaching inn in Rose and Crown Yard off Briggate, looking towards Lands Lane in 1887. From 1783 the Defiance coach ran from here to Hull. It was demolished to make way for the Queens Arcade in 1889. Lighted signs advertise for Binks's Bars No. 1 and No. 2 and billiard rooms. Binks's Hotel is named after the landlady, Maria Binks. Opposite is the Morley Dining Room which offers ladies rooms, good beds, tobacco and cigars. The modern photograph shows The Ship, next to Pack Horse Yard.

The Albion Hotel, Briggate
The Albion was built in 1824 and rebuilt (as here) in 1874 on the east side of Briggate at No. 142. The archway leads onto Albion Yard where there were stables and coach houses. It was all demolished to make way for F. W. Woolworth Co. which opened on 1 December 1928 – Leeds's second Woolworths. The magnificent façade of The Horse & Trumpet in The Headrow is the subject of the new photo. Dating from 1825, the pub has long been associated with the Yorkshire Hussars Cavalry Regiment (originally the 1794 Yorkshire West Riding Yeomanry), hence all of the cavalry paraphernalia on the façade.

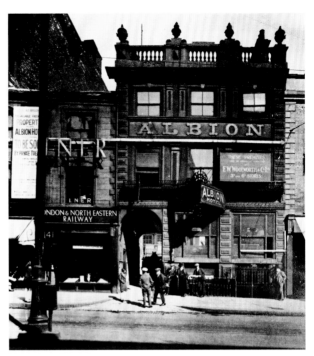

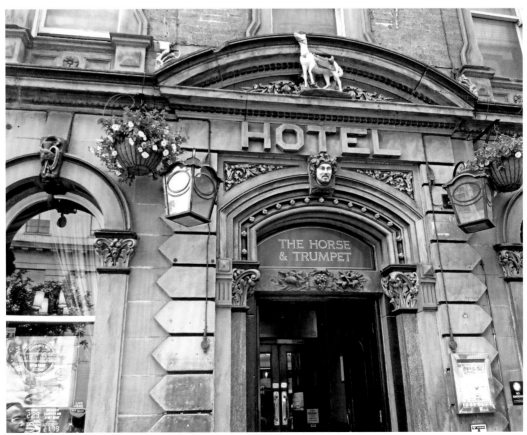

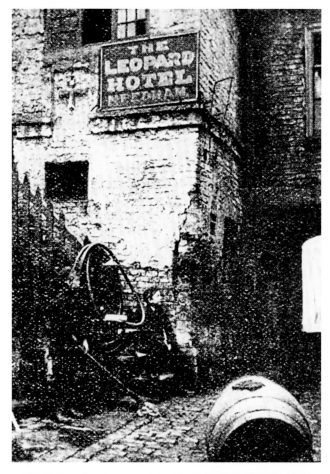

The Leopard, Briggate

A popular haunt of clothiers from Farsely. Daniel Defoe describes the importance of pubs to the clothing industry in Leeds; he observed that the cloth market was a swift, early-morning affair starting at 7 a.m. and was all over by 9 a.m. when it was time for a good breakfast, taken at public houses near the bridge. These meals were called brig-end-shots, which, according to Ralph Thoresby, 'the clothier may, together with his Pot of Ale, have a Noggin o' Pottage, and a Trencher of either Boil'd or Roast Beef for two Pence'.

A very different creature features in the City Museum where a resplendent Roman mosaic resides, depicting the legendary she-wolf Lupa suckling Romulus and Remus, founders of Rome. It dates from *c.* 250 and was discovered at Aldborough. (Isurium Brigantum, www.leedsmuseum.co.uk)

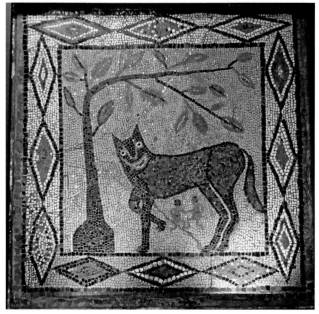

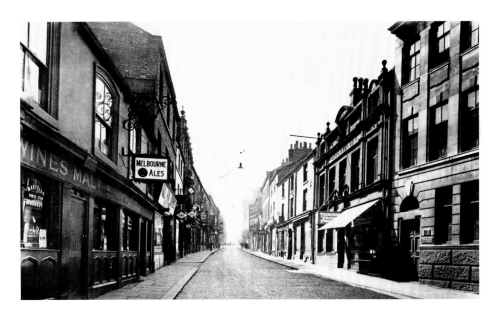

The Malt Shovel and the Unicorn Inn

Over the road from each other in Lower Headrow – or Lowerhead Row as it was called then. On the left at No. 26 is the Malt Shovel; at No. 31 is the Three Legs inn and further down, The Vine. Youngman's fish shop is visible on the right; the Osborne Commercial Hotel is even further down on the left. The lower image is the Crown & Anchor in North Street in 1901. The landlord William Francis Allanson served Tetley's Fine Ales and offered good stabling and accommodation for cyclists. To the left is the Victoria Inn, serving Bentley's Beer; the landlord was N. Hutchinson. To the right are dining rooms, run by Mrs Charlotte Ann Dawson, and a barber's shop, run by William Williams.

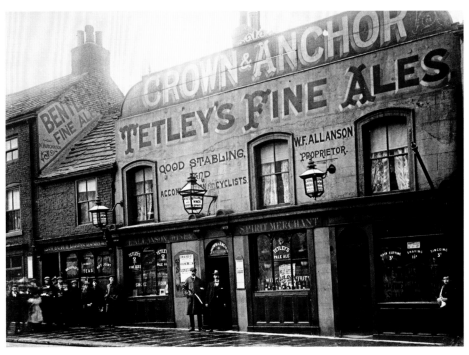

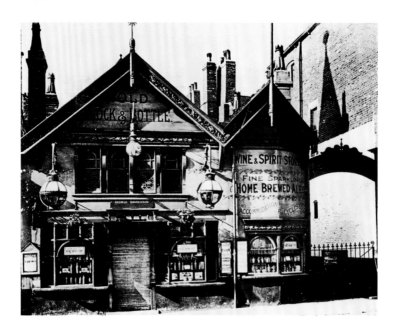

The Old Cock & Bottle, 1906

Formerly a coaching inn, this was an eighteenth-century coaching inn on the junction of Upperhead Row (No. 18) and Guildford Street. It was always popular with the casts and crews at the Hippodrome behind it. In 1938, it was sold to Snowden Schofield and was part of his store until it was demolished in 1961. The Market Tavern, known as The Madhouse in 1914, near the Kirkgate Markets, on the corner of Harewood Street and George Street, won its nickname from the civil unrest which was a frequent occurrence in the pub. The photo is looking from Ludgate Hill. Apparently, there was a one-armed bar steward working there called Eli who had a lot of girlfriends. It was not a place for the faint-hearted and a comment on the Leodis website states that there was 'a regular who had what looked like a thimble stuck on his nose, turned out someone bit the end of his hooter off in a scrap, it was recovered and sewn back on at the nearby Public Dispensary. I don't think the surgeon would have earned much in the tailoring trade!' George Day, brass founder and finishers, can be seen on the left with premises at the back of George Street.

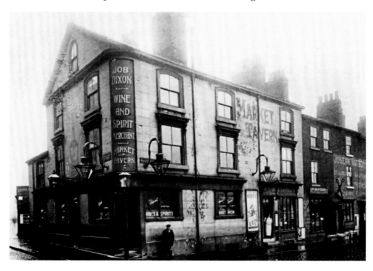

Whitelock's Ale House, 1715, on Turk's Head Yard off Briggate

Grade II-listed Whitelock's Ale House first opened its doors in 1715 as the Turk's Head Inn, fittingly enough, on Turk's Head Yard. It is Leeds's oldest surviving pub. In 1867, John Lupton Whitelock, a flautist with the Hallé and Leeds Symphony Orchestra, was granted the licence of the Turk's Head. The Whitelock family bought the pub and in 1886 completed a refurbishment which has left the decor we can see today, including the long marble bar, etched mirrors and glass.

In the mid-1890s, the pub was rebadged as Whitelock's First City Luncheon Bar and in 1897 John Lupton Whitelock installed electricity, including an exciting new revolving searchlight, at the Briggate entrance to the yard. Trick beer glasses in which a sovereign was placed ensured the punter got, not the money, but an electric shock. John Betjeman described Whitelocks as 'the Leeds equivalent of Fleet Street's Old Cheshire Cheese' and 'the very heart of Leeds'. One of the Great Bars of the World, the pub rubs shoulders with the Long Bar in Shanghai's Peace Hotel and Harry's in Venice.

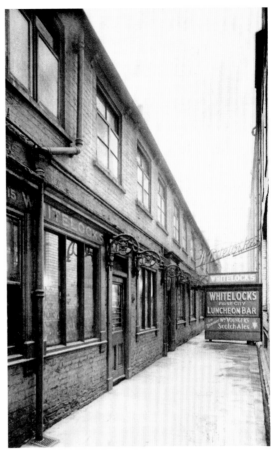

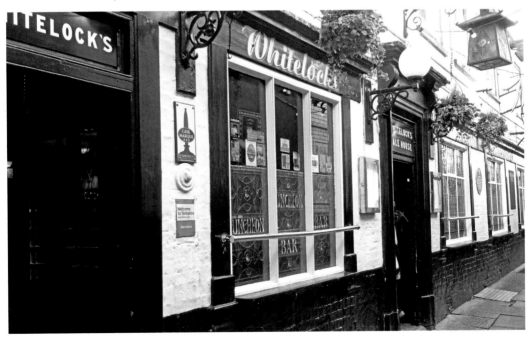

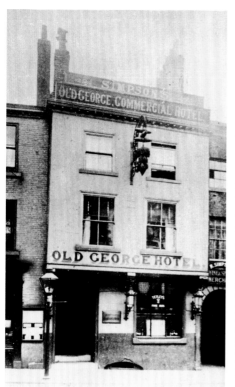

The Old George Commercial Hotel

Located on the east side of Lower Briggate, the Old George Commercial Hotel closed in 1919. There is a Templar cross on the façade indicating that it was originally owned by the Knights Templar in the thirteenth century. In the seventeenth century, it opened as Ye Bush. The name was changed in 1714 to The George; the 'Old' was supplemented around 1815 when the George & Dragon opened nearby. It was known as Simpsons Commercial Hotel after the Simpson family who ran it at the turn of the century. Celia Fiennes stayed here on her horseback journey around Britain; Charlotte Bronte once visited and drew on this in her illuminating description of the pub in *Jane Eyre*. It closed down around 1919 when the licence was not renewed and was demolished shortly after. The owner was William J. Cudworth, a York Quaker who had inherited the pub and with it a dilemma – he was obviously opposed to alcohol. He determined, however, that he would keep it open until the existing landlady, Mrs Simpson, died. Headrow House in The Headrow is in the new picture, converted from a nineteenth-century textile mill in Bramley's Yard.

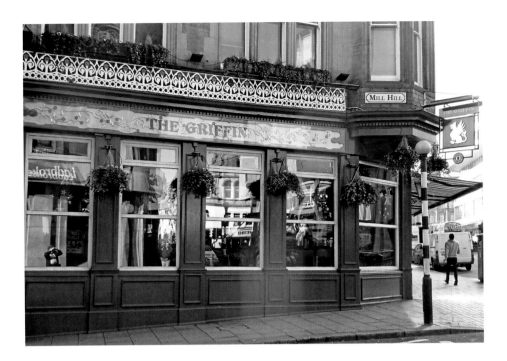

The Griffin, 1872, Boar Lane

The pub is on the site of the earlier Griffin Hotel, a coaching inn from at least the seventeenth century. The building was restructured as a railway hotel for the new station which opened in 1869 and was owned by the joint London and North West and North East Railway. The Gothic Revival building boasted a unique Potts clock at its corner with the hours ingeniously replaced by the words 'Griffin Hotel'. For many though, the Griffin will be cherished as the place where Leeds United was born.

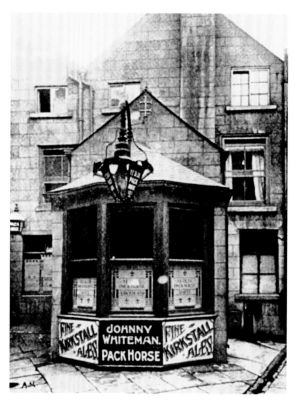

The Pack Horse

The Templar cross can be seen at the front of this ancient pub in Pack Horse Yard off Briggate. The cross tells us that it was originally part of the manor of Whitkirk and it was owned by the Order of St John of Jerusalem, successors to the Knights Templar. It opened in 1615 although there may have been a drinking house on the site in the sixteenth century; some say it goes back to the 1130s. In 1615, it was the Nag's Head and then the Slip Inn from 1770. It was renovated in 1982 when fifteenth-century elements were discovered. The Harrison Arms in Harrison Street and the Old George Commercial Hotel also bear a Templar cross.

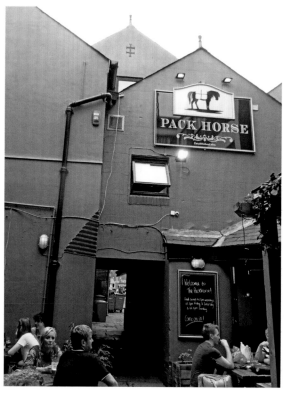

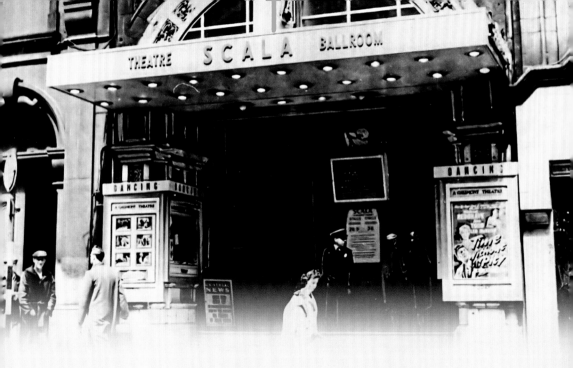

CHAPTER 8

Picture Houses

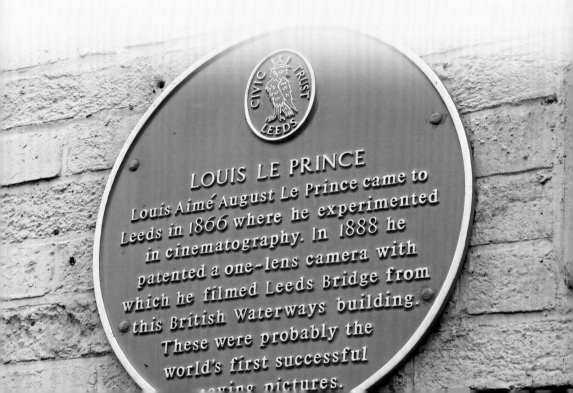

LOUIS LE PRINCE

Louis Aimé August Le Prince came to Leeds in 1866 where he experimented in cinematography. In 1888 he patented a one-lens camera with which he filmed Leeds Bridge from this British Waterways building. These were probably the world's first successful moving pictures.

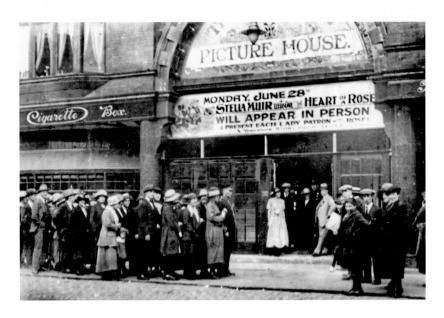

The Odeon, 1946

At the junction of Briggate and The Headrow, the Odeon originally opened as the Paramount Theatre with *The Smiling Lieutenant*, starring Maurice Chevalier, in 1932. The Paramount could seat 2,556 in stalls and circle, and boasted the fourth largest Wurlitzer organ in Europe, now in the Thursford Collection in Thursford, Norfolk. The cinema had 1.2 million patrons during its first year. The Picture House on Briggate opened in 1907 with *Henry VIII*, featuring Sir Herbert Beerbohm Tree, and the company of His Majesty's Theatre London. As well as the cinema, the building housed the Jacobean, a smoke room for gentlemen, and the Wedgwood Tea Lounges for ladies, with writing tables, magazines, papers and light refreshment provided. The Picture House was renamed the Rialto in 1927. It closed in 1938 and was demolished in 1939 to make way for the new Marks & Spencer.

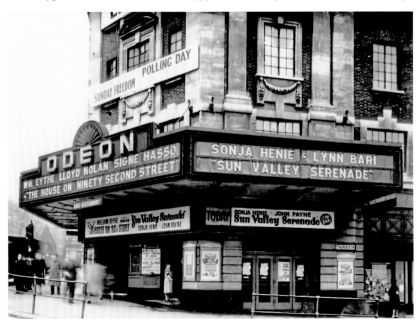

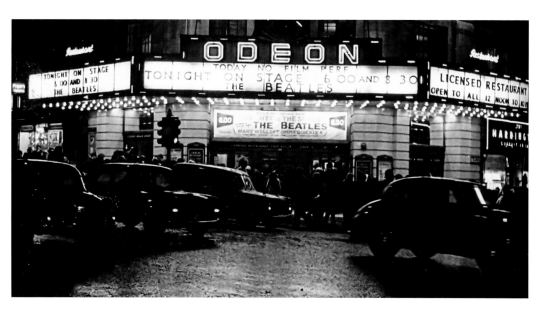

The Beatles at the Odeon

The Beatles played the Odeon three times: June and November 1963 and 22 October 1964, shown here. On 28 June they performed at Leeds Queens Hall. The October gig was the eleventh date of The Beatles' 1964 British tour and their final visit to Leeds's Odeon Cinema. They performed two sets, for which they were paid £850. Their set comprised ten songs: 'Twist And Shout', 'Money (That's What I Want)', 'Can't Buy Me Love', 'Things We Said Today', 'I'm Happy Just To Dance With You', 'I Should Have Known Better', 'If I Fell', 'I Wanna Be Your Man', 'A Hard Day's Night' and 'Long Tall Sally'.

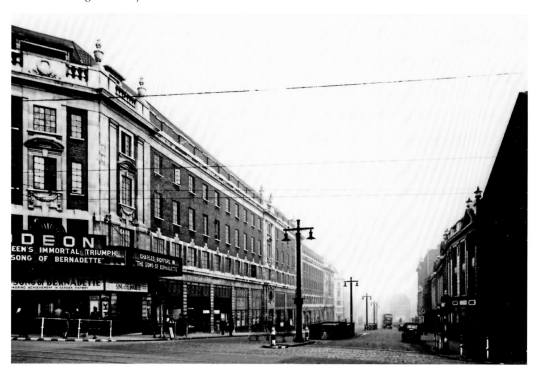

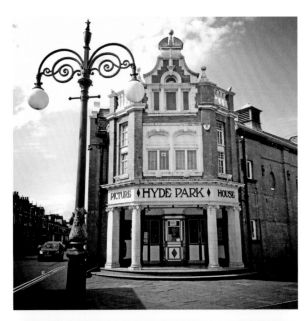

The Hyde Park Picture House, Brudenell Road

This Grade II-listed picture house started life in 1908 as a hotel, and in November 1914 was converted into the cinema which still retains its nine gas lights, the decorated Edwardian balcony and the original organ and piano. With its 280-seat auditorium the picture house has kept its two 35-mm film projectors which are still in use – especially during Leeds International Film Festival, where the cinema serves as a principal venue. The ornate lamp outside the entrance is also Grade II-listed but no longer gas-powered. Apart from patriotic films, the picture house also showed the anxious people of Leeds newsreel of the war so they could learn about the 6,000 men from the city who had enlisted. Some were reliant on the picture house news because many of them could not read the newspapers or afford a wireless. (Courtesy of Ollie Jenkins)

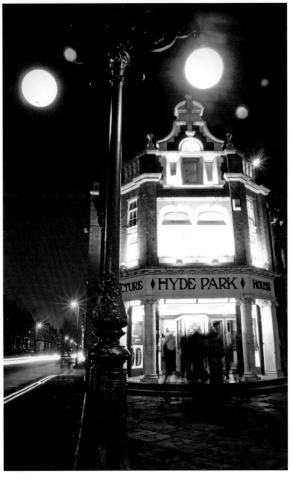

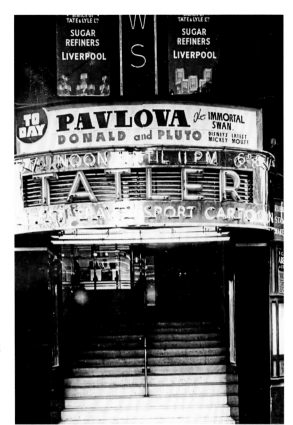

The Tatler

Discerning cinema-goers apparently came to the Tatler. The Plaza (below) was originally called the Assembly Rooms and is situated next to the Grand Theatre. Films were shown from 1907, and it soon established a reputation for salacious and exotic fare. The Plaza closed in 1985 and is now used as a rehearsal room by the theatre. The photo on page 89 shows the Scala. The Scala opened in 1922. *Snow White and the Seven Dwarfs* (1937) had its Leeds premiere here and *Hamlet* played to capacity houses for nine weeks in 1948. The Scala closed in 1957. The lower image shows where it all started.

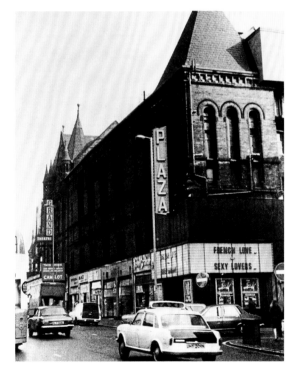

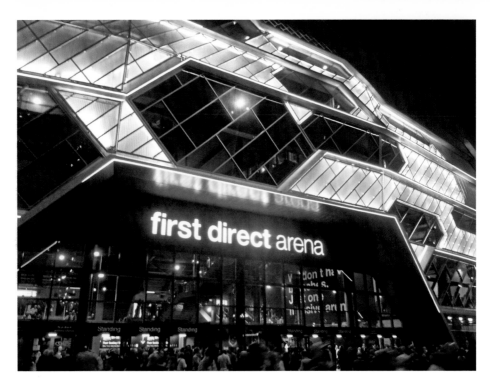

Neil Young Live at Leeds – 'Like a Hurricane'

Neil Young performed here in June 2016. First Direct Arena opened in 2013 and is the first in the UK to have a fan-shaped orientation as opposed to the more usual bowl or horse-shoe seating arrangement. The arena boasts 'perfect sightlines' from every seat; the longest distance from the stage is a mere 68 metres compared with the 95–110 metres of traditionally designed arenas.

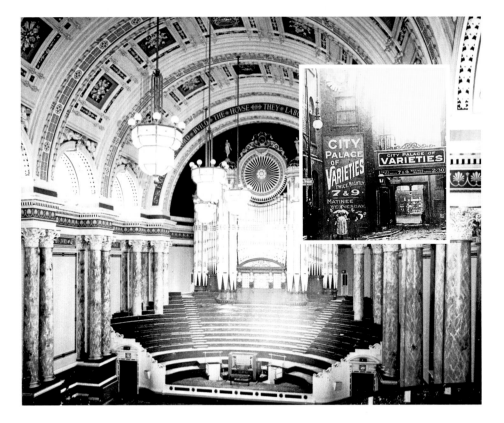

City Varieties Music Hall

In 1760, City Varieties was born when the White Swan Coaching Inn was built in a yard off Briggate, on the White Swan Yard. The White Swan featured a singing room upstairs, where various acts were staged. Charles Thornton became the licensee of the White Swan in 1857 and reopened the new refurbished 2,000-seat venue in 1865 as Thornton's New Music Hall and Fashionable Lounge. It remains a rare surviving example of Victorian-era music halls of the 1850s and 1860s. In 1898, the theatre was sold to Fred Wood who booked acts such as Charlie Chaplin, Lily Langtry, and Laurel & Hardy. When Lily Langtry performed there, Edward VII would visit her. In gratitude for the theatre's discretion, he donated the crest which is now displayed above the auditorium.

Between 1913 and 1915, the theatre held wrestling matches for local men. The Christmas pantomime of 1941, *Babes in the Wood*, featured unique audience participation when a woman in the audience unexpectedly gave birth to a 'healthy ginger-haired boy'. Harry Joseph, the owner, gave the child free admission for life. Even less conventional performances included the lady who hypnotised an alligator to music and, in the 1950s, striptease shows were put on in which the girls were allowed to pose but not move. The lower picture shows Victoria Hall in the Town Hall after its 1978 restoration. The organ swell box was the largest they had ever built; a dinner party was held inside the box at the factory.